IMAGES
of America

MOUNT SINAI

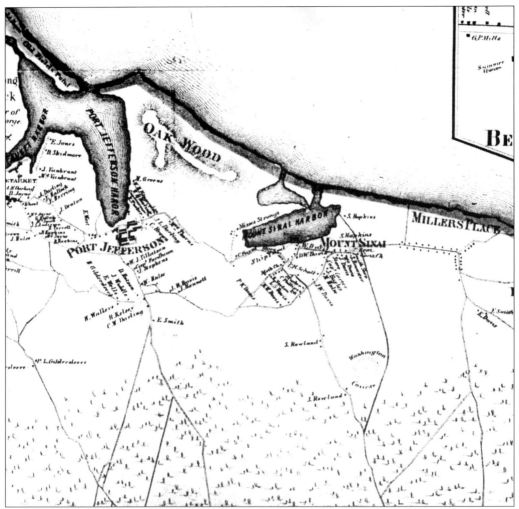

This map was published in 1858 by J. Chace. The Washington Course, located east of Mount Sinai-Coram Road and north of the intersection of Miller Place and Yaphank Road, was probably a horse racing course frequented by local residents. Painter William M. Davis, who lived in "the Snuggery" across from the Mount Sinai Congregational Church on North Country Road, reportedly liked horse racing. During the first half of the 19th century, shipbuilding was done out of Mount Sinai Harbor, and a shipyard is identified on this map. Although shipbuilding continued in Mount Sinai until at least 1874, the industry thrived in the deeper harbor at Port Jefferson and was relocated there. Many Mount Sinai residents continued to work in this important trade and commuted to work in Port Jefferson. Historians in the 19th century noted the "immense quantities of clams" that were dug up from Mount Sinai Harbor and the abundant salt hay along the shore and on the islands in the harbor, as well as the large quantities of cordwood that were sold and marketed by locals through the 1890s. (Courtesy the Department of Special Collections, Stony Brook University.)

IMAGES
of America

MOUNT SINAI

Ann M. Becker

ARCADIA

First printed in 2003.

Published by Arcadia Publishing,
an imprint of Tempus Publishing Inc.
2A Cumberland Street
Charleston, SC 29401

Printed in Great Britain.

Library of Congress Catalog Card Number: 2003105603

For all general information, contact Arcadia Publishing:
Telephone 843-853-2070
Fax 843-853-0044
E-mail sales@arcadiapublishing.com

For customer service and orders:
Toll-free 1-888-313-2665

Visit us on the Internet at www.arcadiapublishing.com.

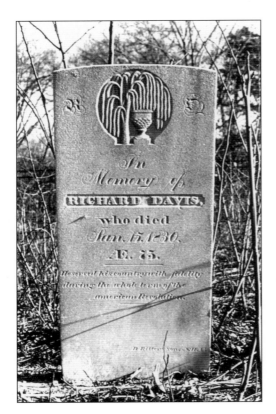

Richard Davis served in the Continental Army during the American Revolution and wintered at Valley Forge. He was born c. 1757 and died on January 15, 1830. Having served for the duration of the war, Davis received a veteran's pension from the federal government beginning in 1818. He is buried in the Phillips and Davis private graveyard on North Country Road in Mount Sinai.

CONTENTS

Acknowledgments 6

Introduction 7

1. Old Mans 9

2. Hamlet on the Harbor 29

3. Playground of New York 47

4. Beautiful Mount Sinai 65

5. A Farming Community Transformed 91

6. Development and Preservation 107

ACKNOWLEDGMENTS

This book would not have been possible without the generosity and enthusiasm of the Miller Place-Mount Sinai Historical Society and the phenomenal assistance of society president Edna Davis Giffen. Edna spent hours illuminating the history of Mount Sinai for me and shared the collections of the society with me without reservation. For all her help, I am truly grateful. Other community residents, many of whom are descendants of early settlers to our hamlet, were equally generous and have my sincere gratitude. Harry and Florence Randall shared their collection of historical documents and photographs, as well as their memories of days gone by in Mount Sinai. Honor and Johnny Kopcienski and Fred Drewes helped me get started with the project months ago. Brookhaven town historian David Overton and his assistant, Mallory Leoniak, photocopied records and documents for me. David Allen and Kristen Nyitray at Stony Brook University opened their map collections to me. Dr. David Bernstein shared information about the archeological heritage of Mount Sinai, and Margaret Alfano shared her many photographs and memories with me as well.

Many thanks go to Jane Edsall and her family; Barbara Davenport and her children; and Brother Jason Robert, on behalf of the Little Portion Friary, who all shared precious photographs with me. I would also like to thank Maureen Poerio at the Mount Sinai school district office; Judy Randall at the Mount Sinai Fire Department; Dennis Murphy at the Mount Sinai Congregational Church; Victoria Bender; Kristen Metzler; Lori Baldassare; Deirdre DuBato; Nadine Knoernschild; Warne Randall; Joan Van Middelem; Bill Wolf; Gary Swett; Dr. Sherman Mills; Dr. Lee Koppelman; Barbara LoRusso; Chip Bergold; Dagmar and Robert Von Bernewitz; Connie Gaudio; and Sandy at Ozone Aerial Photo. Special thanks go to David and Karen Abramowski, whose generous assistance permitted me to include a photograph of great importance to this work. I would also like to thank my husband, Walter, and daughters Katie, Mary Ellen, Alison, and Lyndsay, who support and encourage my endeavors with patience, understanding, and love.

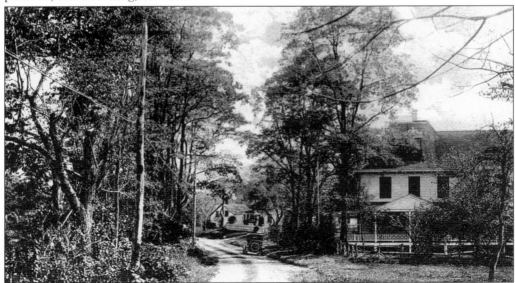

This 1925 postcard was photographed by R.S. Feather.

INTRODUCTION

Mount Sinai covers the history of this beautiful North Shore hamlet on the harbor from its inception as one of the oldest settlements in Brookhaven, Suffolk County, Long Island, to the present day.

The community, known as Old Mans during Colonial times, was officially established in 1664, when Native Americans sold land to the town of Brookhaven for goods, including coats, stockings, shirts, kettles, knives, and hatchets. The original name for the Mount Sinai community is explained in three different ways. According to local legend, a Colonial swindler named John Scott finessed one Major Gotherson, a wealthy aged Briton, out of 10,000 pounds with a fraudulent land deal. Another suggests that the name originated from the sale of land by Native American Sachem Massatewse, chief of the Setauket tribe, to the town of Brookhaven in 1664. Still, a third story attributes the name to a 17th-century tavern owner in the area. In any case, the name was changed to Mount Sinai in 1840, when the local postmaster or his wife purportedly randomly pointed a knitting needle at his open bible and chose the name closest to the point of the needle.

Mount Sinai was home to a large Native American population over 5,500 years ago. At this time, the area was known as *Nonowantuck*. Long Island's north coast offered sheltered harbors and coves with easily available food supplies, resources needed to manufacture stone tools, and convenient transportation for canoes. While relying on hunting, gathering, and fishing, early Native American populations also established long term settlements on Mount Sinai Harbor. The Native American village was located on the south shore of the harbor, and archeologists believe it was one of the most densely populated areas in the Long Island Sound region. Local residents can still find artifacts left behind by the hamlet's first residents.

During the American Revolution, a patriot raiding party landed at Cedar Beach and made its way across Long Island to the Manor of St. George in Shirley, where they burned British supplies. The Tallmadge Historical Trail, which begins at Cedar Beach, commemorates this daring feat. Mount Sinai residents served in the American army during the Revolution and endured the British occupation of Long Island or relocated for the duration of the war.

Numerous well-preserved historical homes and buildings line the historic district along North Country Road in Mount Sinai, including the Davis house, the Tillotson house, and the Congregational church. Other historic homes include the Ketchum house, the Selah Homan house, and the Theodore Velsor Davis house.

Early settlers engaged in shipbuilding, farming, and fishing, and cut and sold cordwood. Cash crops included wheat, rye, buckwheat, and corn. Sheep were raised for wool and meat, and most farms had dairy cows and pigs. Blacksmiths, shoemakers, schoolteachers, salesmen, shopkeepers, and storekeepers all lived and worked in Mount Sinai. Windmills and gristmills were built in the area. The harbor provided a variety of shell and finfish, and many residents pursued careers at or on the sea during the 19th century.

Mount Sinai has been a pleasant place for vacationers to enjoy the natural beauty of the picturesque hamlet since the 1800s. Wealthy city dwellers spent summers here, and Crystal Brook Park was established in the 19th century as a health resort and private residential community. Satterly's Landing and Davis Island provided recreational facilities for summer visitors. The Long Island Rail Road's Port Jefferson Line ran through Mount Sinai from 1895 until 1939, bringing families to summer cottages on the beach and children to the various camping facilities in the area. Vacationers could stay in private homes or small hotels in the area. Authors and actors, such as Mark Swan, Lionel Barrymore, Dawn Powell, Norman Rosten, and Arthur Miller, sought or rented homes in Mount Sinai. Marilyn Monroe visited

Cedar Beach and the nearby Chandler Estate during the 1950s. Active community residents maintained the school district, ran the post office, set up a fire department, and established churches, a civic association, a historic district, and a historical society.

Long famous for the locally grown peaches sold at the Davis Peach Farm stand on Route 25A, vestiges of Mount Sinai's farming heritage still remain, although modern suburban development has eliminated much farm acreage. Early residential developments such as the Artists' and Writers' Colony advertised life in Mount Sinai as "the most beautiful spot on the wonderful North Shore." More modern suburban development beginning in the 1960s changed the community significantly, but farming and maritime activities continue in Mount Sinai, as they have for generations.

Today, the harbor and Cedar Beach are used year-round for recreational and commercial activities, including swimming, boating, hunting, clamming, lobstering, and fishing. Mount Sinai's harbor, formed by glacial activity, is 455 miles in area. Predominantly salt marsh, mudflats, and open waters, the southern part of Cedar Beach has been heavily developed as a marina and boat mooring area. State environmental laws are now in place to protect the wetland areas in Mount Sinai, after controversial sand dredging changed the harbor ecology forever. A nature study center maintained by the town of Brookhaven preserves a small portion of the original sand dune and provides educational opportunities for residents and visitors alike. Recent preservation efforts have ensured that residents will continue to have open space protected and available for passive and active recreation and will sustain a sense of the heritage and history of this beautiful hamlet.

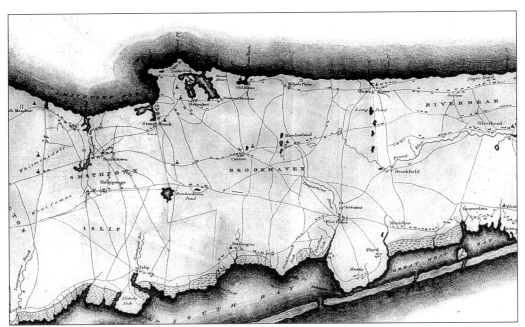

This map, published by David Burr in 1829, located areas called Old Mans and Old Mans Harbor on the north shore of Long Island. The area's Native American name, *Nonowantuck*, meaning "a creek that dries up," originally identified the Mount Sinai-Miller Place area. On 17th-century maps, the hamlet is located near Scots Hole, which was a home owned by colonial adventurer John Scott, an early American colonist and geographer. (Courtesy the Department of Special Collections, Stony Brook University.)

One

OLD MANS

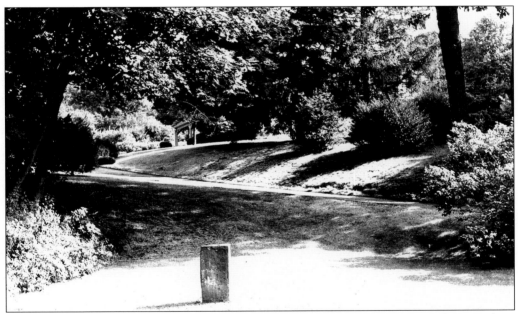

This 18th-century milemarker, located on the south side of North Country Road, across from the Mount Sinai Congregational Church, was used to denote the distance from the Riverhead Courthouse to determine the cost of mailing a letter. Benjamin Franklin instituted the system of milemarkers when he became the first postmaster general in 1753 to standardize postage. The three known markers in Mount Sinai and Miller Place are each exactly one mile apart. A historic district was established in Mount Sinai in this area in 1983, through the efforts of residents Edna Davis Giffen and Debbie Iberger. (Courtesy Dagmar and Robert Von Bernewitz.)

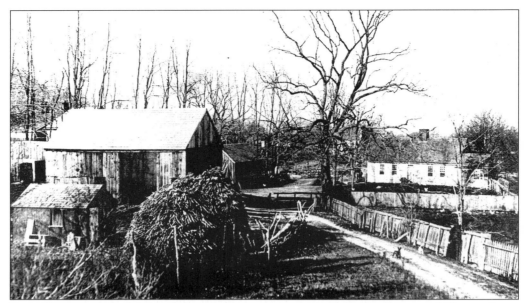

Daniel Davis purchased this farm, which was located on Shore Road, west of Mount Sinai-Coram Road, sometime before 1790. Evidence indicates that portions of this house date to the 1600s, and the farm was probably owned by one of the Norton families. Davis lived here until 1884, when the property was sold out of the family. It remained an active farm until the 1900s.

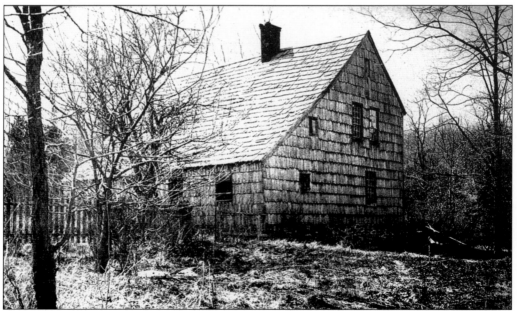

The Benjamin Davis Jr. house, constructed in c. 1705, is the oldest building still standing in Mount Sinai. It was originally built on the east side of Rocky Hill Road with the classic saltbox configuration of a high two-story front and a steeply pitched roof. Benjamin Davis was the grandson of Faulk Davis, the first of the family to settle on Long Island in 1639. Many of his descendants lived in Mount Sinai. The home remained in the Davis family until 1894.

10

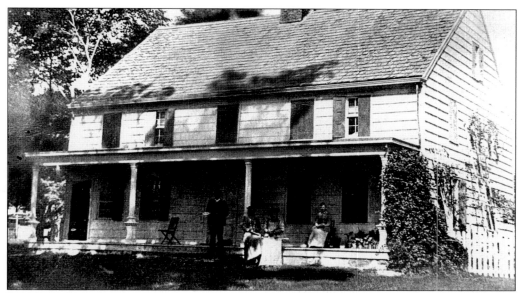

The Davis homestead, on the north side of North Country Road, east of Mount Sinai-Coram Road, is depicted here before modern additions were added. The main house, situated on a 15-acre parcel, was built in the 1680s. A 1720 addition created a saltbox-style home. During the 1820s, the house was known as the Union Hotel and used as a stagecoach stop. The homestead includes several restored original and relocated historic buildings and was home to the Davis family from 1680 to 1934, the Downs family from 1943 to 1959, and the Kopcienski family from 1959 to present.

Brookhaven records indicate that Rocky Hill Road, pictured here, served as the main road to Old Mans Harbor from the upper cart way, or North Country Road, during the 17th and 18th centuries. Before the eastern section of Shore Road was constructed in 1835, the harbor could only be accessed by this road, the road to Old Mans meadow, or the road to Moger's shore.

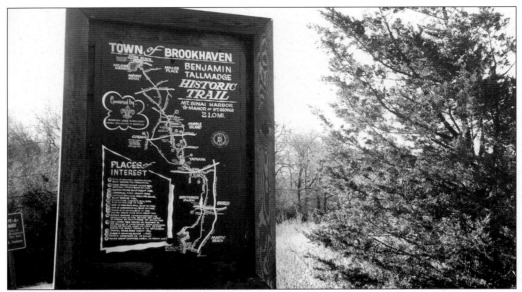

Mount Sinai was the embarkation point for a Revolutionary War raid by the American patriot forces. Maj. Benjamin Tallmadge of Setauket organized a spy ring on Long Island. In November 1780, Tallmadge led a raiding party to destroy a large store of hay being held at Coram and attack the British stockade and fort at the Manor of St. George in Mastic. Eight boats carrying 80 men sailed across Long Island Sound to Old Mans. The men marched south across Mount Sinai. After a successful raid on the fort, soldiers marched back to Coram to destroy the hay, then met at Mount Sinai Harbor and returned to Connecticut. George Washington personally expressed his gratitude to Tallmadge for the completion of his mission.

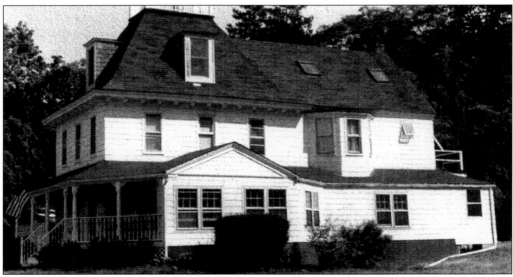

The Selah Homan house on Old Post Road was built c. 1818, but many additions and changes have altered the appearance of the original one-story home. Homan was a tailor and is the only member of the community known to have served in the War of 1812. (Courtesy Dagmar and Robert Von Bernewitz.)

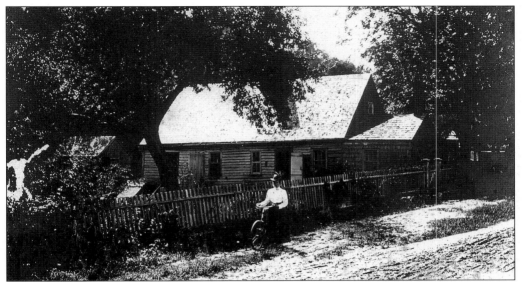

The Conklin-Norton house was originally built in the 1700s. Milford Conklin owned it in the early 1800s and then sold the property to Albert and Emma Davis Norton, who owned the house until the early 1900s. Brooklyn photographer and Mount Sinai summer resident William Van Pelt took this photograph in 1899 and gave it to Lorenzo H. Davis. The lady walking alongside the picket fence is identified only as Mae. In 1922, Beverly Davis tore this house down and replaced it.

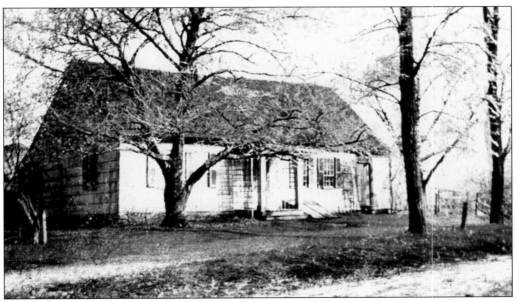

The Joseph Phillips house, built in the 1720s for the Phillips family, served as the Mount Sinai post office beginning in the 1840s, when Charles Phillips, the first postmaster, lived there. Charles Phillips's son John W. Phillips became postmaster for one year in 1884, and he sold the house to John S. Randall of Miller Place that same year. John Randall served as postmaster from 1885 until he died suddenly in 1886, leaving his 16-year-old son, Forrest, to run the family farm.

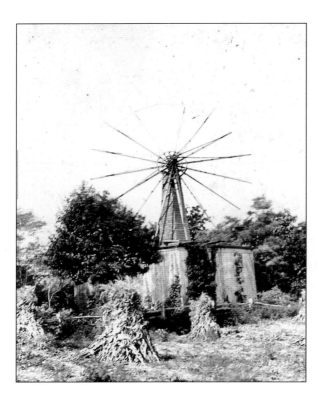

This wind-powered gristmill was built and operated by Richard Tillotson during the 1880s. According to a 1924 article by Capt. Daniel S. Davis of Davis Island in the *Port Jefferson Echo,* the building originally stood in Rocky Point and was moved to Mount Sinai by Tillotson.

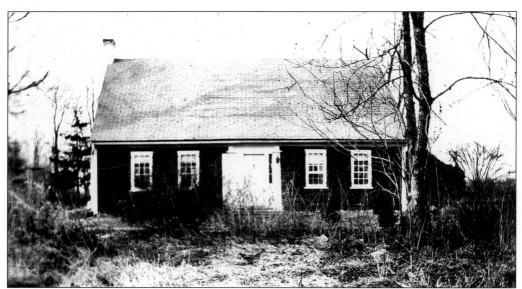

Located on the north side of North Country Road, east of Mount Sinai-Coram Road, the framework for the this 18th century home, begun at another location by Nathaniel Miller, was purchased by Richard Davis, who served for seven years during the American Revolution, sometime before 1790. Sea captain Richard Tillotson owned the house during the mid-1800s. The Gracey family purchased the home in the 1940s.

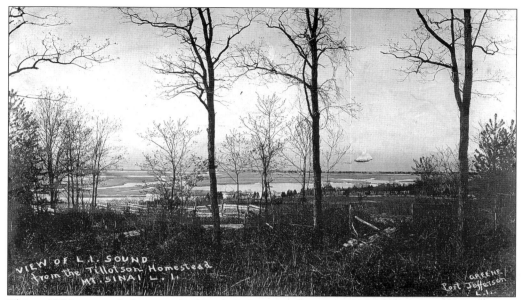

This c. 1900 postcard photographed by A.S. Greene offers a view of the harbor as seen from the Tillotson house. Greene was a professional photographer who worked actively on the north shore of Brookhaven from 1894 until his death in 1955. He had a studio in Port Jefferson and took many photographs in Mount Sinai. Early access to the harbor was mainly via Rocky Hill Road, which runs behind this home. The marshland areas seen here were removed in later years with extensive harbor dredging.

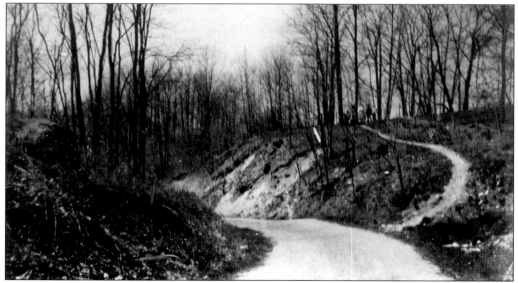

This postcard depicts New Road, originally opened in 1792. It was constructed to improve access to the harbor area, and it extended from North Country Road to Shore Road West. The pathway to the right shows the original route of the roadway. Residents were required to dedicate a certain number of days to the road district or pay a fee in lieu of labor in the days before municipal highway departments. The town of Brookhaven changed the name of the road to Mount Sinai-Coram Road sometime in the 20th century.

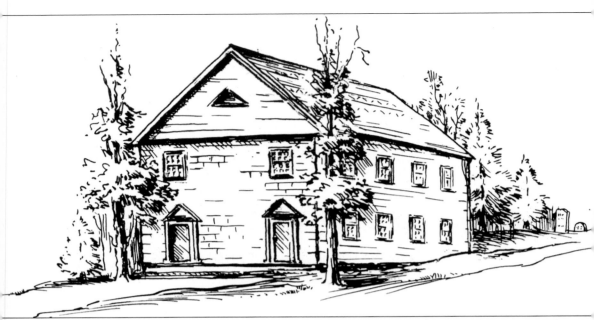

The Mount Sinai Congregational Church was established in 1789 as the Strict Congregational Church of Old Mans. Noah Hallock served as the first minister for a congregation of 12 from 1790 to 1818. Residents Thomas Strong, Andrew Miller, and Joseph Davis had constructed a church building on Davis's land west of the present church building in 1740. Though extensive repairs to the 65-year-old meetinghouse were made in 1805, by April 1807, parish leaders began to raise funds for the construction of a new church building. This sketch depicts the church as it would have looked upon its completion in 1807.

Mount Sinai was originally known as Old Mans until the post office in the area officially changed its name to Mount Sinai in 1842. Residents originally chose the name Mount Vernon once Old Mans was deemed inappropriate, but the state already had a town by that name. Local legend holds that postmaster Charles Phillips or his wife selected the name Mount Sinai from the Bible by closing his or her eyes and pointing a knitting needle at a randomly selected page.

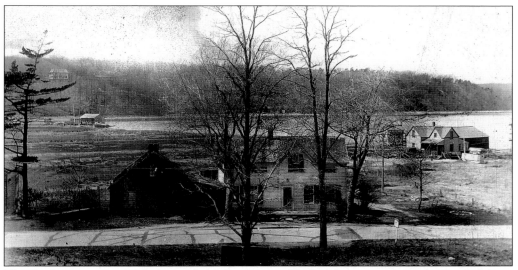

This harbor view *c.* 1900 shows the John Waters Tooker house in the foreground, Minor Satterly's dock on the right, the Davis boatyard on the left, and the Crystal Brook Park section of Mount Sinai across the water. The original Tooker house, torn down sometime in the early 1900s, is seen in the left of the photograph. The building was sold to John Hutchinson, and the house eventually went to Selah Tooker when he married Hutchinson's daughter Clarinda.

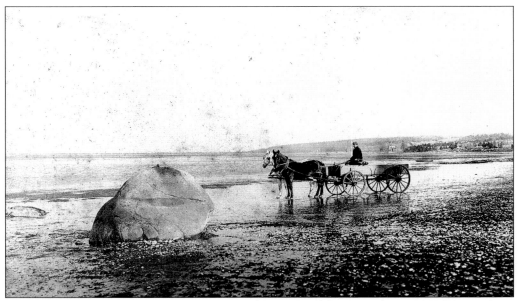

This photograph shows Lorenzo H. Davis with a team of horses and wagon at Mount Sinai Harbor near a large rock. Notice the ring at the top of the rock used to tie boats. This rock is a well-known landmark in the harbor located at the end of Shore Road East at what was called Moger's landing. John and Hugh Moger built what is believed to be the first home on the harbor in the 1600s. A sea wall was built in this area after 1910 to prevent the road from flooding.

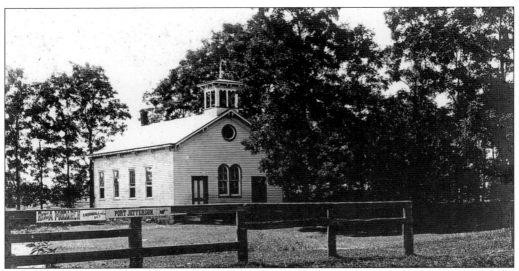

Mount Sinai's second public school was built in 1870 on the corner of Mount Sinai-Coram Road and North Country Road, where the main firehouse now stands. Children had been educated in the district since its establishment in 1813, although records indicate the existence of an earlier private seminary taught by George Hopkins. Although the location of the original public school is unknown, tradition has located it on the north side of North Country Road, east of Mount Sinai-Coram Road. Notice the signs on the fence advertising an automobile dealership. One reads, "Ride a Monarch, A N Randall, Port Jefferson."

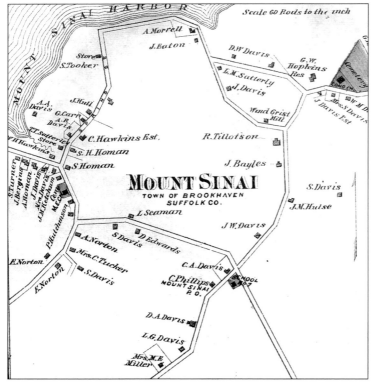

This map of Mount Sinai, published by Beers, Comstock, and Cline, depicts the locations of local families and buildings in 1873. Such old Mount Sinai family names as Carr, Tillotson, Norton, Davis, Ketchum, Miller, Bayles, Satterly, Tooker, and Hopkins are well represented. The Mount Sinai Congregational Church and local school are also pictured on the map. A Methodist-Episcopal church, built in 1846 on the north side of Shore Road, west of Old Post Road, is also seen here. (Courtesy the Department of Special Collections, Stony Brook University.)

The Mount Sinai Congregational Church celebrated its centennial anniversary on December 23, 1889. Pastor Reverend E.A. Hazeltine presided over the celebration, which included singing, scripture reading, and prayer. Recent improvements to the church included the construction of a choir loft.

DEC. 23, 1789. DEC. 23, 1889

Centennial

✦ SERVICES ✦

— HELD AT THE—

Congregational Church,

—IN—

MT. SINAI, NEW YORK,

DECEMBER 31st, 1889

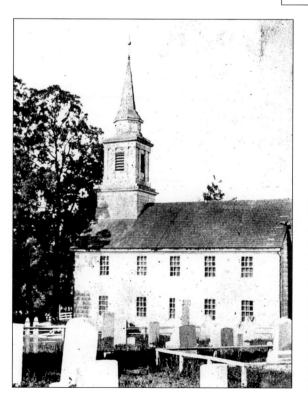

Several additions to the church building had altered its appearance considerably since its original construction in 1807. In 1836, a yellow pine fence with locust boards was erected around the church. A vestibule extension added ten feet to the south end of the building in 1851. Parish clerk Samuel Hopkins, who declared he had never seen a church without a steeple, became personally responsible for adding the steeple at this time. This is a postcard of the building as it appeared in 1905.

19

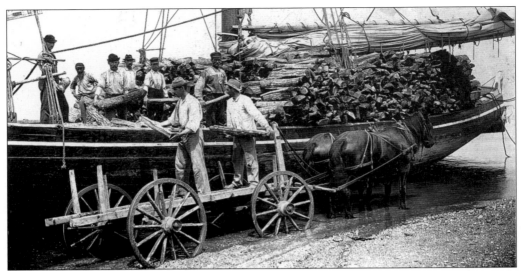

Cordwood was the best available cash crop for local farmers and residents from the 1700s through the late 1890s. Coastal schooners would anchor on the beach at high tide, and at low tide men would load cordwood while the boat sat on the beach. The wood went to New York City or to the brick kiln factories in the Haverstraw area along the Hudson River. This view shows men loading the *Emma Southard* at Mount Sinai Harbor *c.* 1890. Pictured from left to right are James W. Davis, Charles Sells, Frank Satterly, Gus Tooker, Lewis Satterly, and Capt. Daniel Davis. Pictured in front of the boat are Forrest B. Randall and Lorenzo H. Davis.

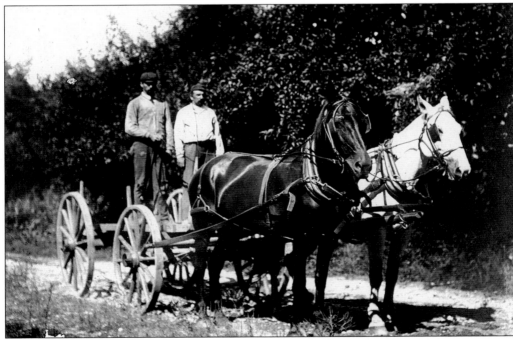

Lorenzo H. Davis and his uncle James B. Davis are pictured here with a horse and wagon used to haul cordwood. This photograph was taken by Brooklyn photographer William Van Pelt and given to L.H. Davis in 1899.

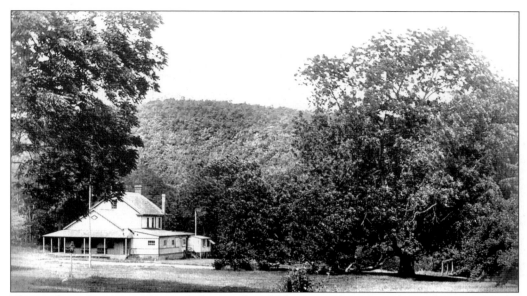

This early-20th-century postcard depicts the old homestead at Crystal Brook. In 1655, the plantation of Brookhaven was established, and in 1664, the sachem Massatewse and Sunke Squaw, widow of Sachem Warawasen or Wiadance, deeded to the town of Brookhaven all the lands from the "Ould Mans" to the Wading River. The price included four coats, four pair of stockings, chests of powder, hatchets, knives, and kettles. In 1668, the town allotted John Tooker a 50-acre parcel, "No. 35, being Crystal Brook Neck." Benjamin C. Payne, a Tooker descendant, eventually inherited the land in 1858. Payne's daughters sold the property to the Crystal Brook Park Association on April 2, 1892.

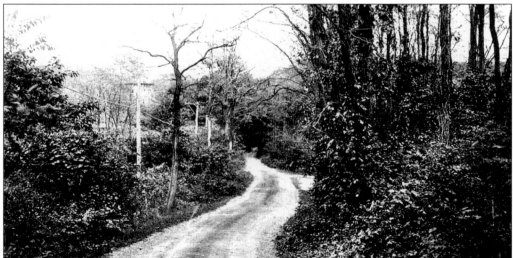

Local photographer R.S. Feather took this photograph of Crystal Brook Road in the early 1900s. Dr. Jerome Walker of New York City established the community of Crystal Brook Park as a health retreat and private summer community in the late 18th century. Walker and his wife rented a summer home in Mount Sinai in 1887, and they began this resort at Crystal Brook Neck soon after. The private community is located on Crystal Brook Hollow Road off Old Post Road along the harbor.

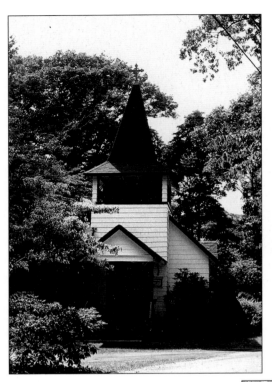

Elizabeth H. Burritt built this non-sectarian chapel in 1902 in memory of her husband, Lewis Wilmont Burritt. She also built two cottages in Crystal Brook Park in 1895, Rustic Lodge and Chestnut Burr. (Courtesy Dagmar and Robert Von Bernewitz.)

This view is within Crystal Brook Park, with the clubhouse, built c. 1902, visible on the left. The clubhouse burned to the ground in 1964 and was rebuilt the following year. Part of the old homestead of Crystal Brook may have been one of the buildings erected by John Scott, depicted on 17th century maps as Scotshole and sold at auction to Zachariah Hawkins in 1665, when Scott's assets were seized by the government. Native American Sachem Massatewse lived in Crystal Brook, then called "the Neck."

The Mill Pond, located at Crystal Brook in Mount Sinai, was used through the beginning of the 18th century. The force of this stream was sufficient to power a mill at the site, which likely ground grain. Brookhaven granted Richard Davis the use of Crystal Brook for a water-powered fulling mill, used to thicken and cleanse cloth, in 1700, but it is unclear if he built the mill. Town records do indicate that Christopher Perkes built a fulling mill sometime after 1702. Moses Burnett had a gristmill on this site in 1718. The Mill Pond dam broke in the 1970s.

This view of the Selah Strong homestead in Belle Terre was taken from the Crystal Brook area. Mount Sinai resident Bartlett Conklin recounted a legend that Setauket Chief Massatewse, who lived on the bluff at Crystal Brook, used an underground tunnel to get from the top of the hill to the shore, allowing him to evade intruders and escape unobserved to his canoe below. According to a pamphlet published on the occasion of the 75th anniversary of Crystal Brook, an old rock-lined cave and a tunnel were discovered at Crystal Brook when one of the cottages was constructed.

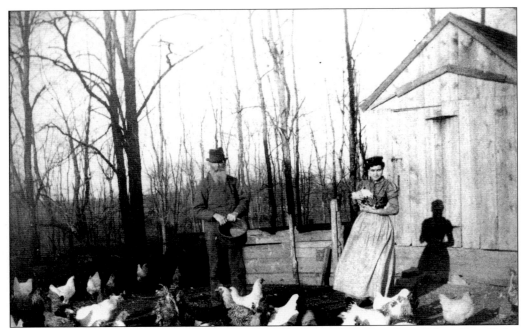

This early farm scene depicts the chicken coop on the farm of Lorenzo G. and Ann Eliza Hulse Davis during the 1890s. The farm was located on the north side of North Country Road. Angie Davis, youngest daughter of Lorenzo, is pictured on the right. Below is a view of the farm's pigs. Raising livestock, especially chickens, pigs, and cows, was an important part of farm life.

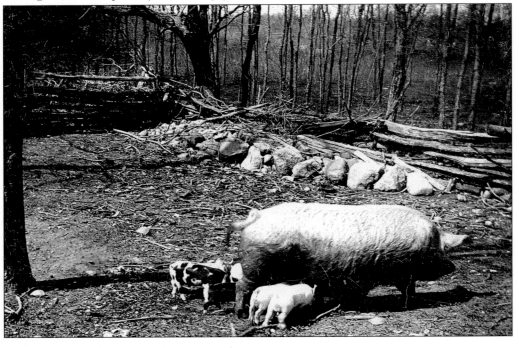

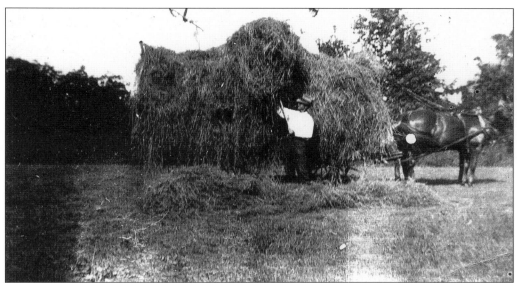

This photograph shows hay being gathered by hand. The hay would then be carted by horse and wagon to the barn for storage and used to feed the farm animals during the winter months. Below, workers pose while engaged in chopping wood for use on the farm. This farm was eventually inherited by William Van Pelt Davis, who farmed here through the 1970s, when part of the property was sold for residential development, and a portion was sold to the school district.

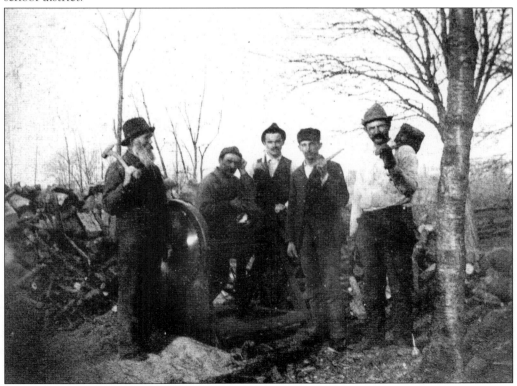

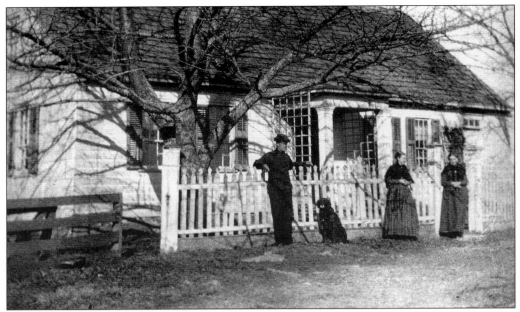

This c. 1885 photograph depicts the Phillips-Randall home with a wooden roof. Note the "coffin door" to the far right of the house added to accommodate home wakes and funerals. In front are, leaning on the fence, John S. Randall with his dog, his wife, Eliza Catherine Davis Randall, and his aunt May Tuthill. Randall served as Mount Sinai postmaster for one year. Eliza Catherine became postmistress upon the sudden death of her husband John in 1886, and served until 1907. The Randalls' daughter Edna Lamella is pictured below with a horse c. 1900.

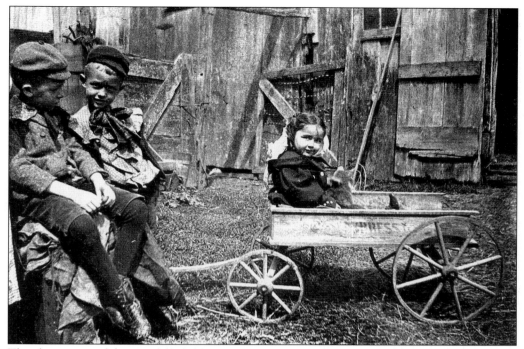

The above view of the Randall children at the William Van Pelt Davis farm on North Country Road dates from c. 1900. Below is a picture of Edna Lamella Randall and her mother Eliza Catherine Davis Randall in 1899, seated on the porch of the Phillips-Randall house, which served as the Mount Sinai post office from 1840 to 1907. Both photographs were taken by William R.P. Van Pelt, a Brooklyn photographer and longtime summer resident at Mount Sinai. He took many pictures of the people and places in Mount Sinai, and his images provide a well-documented history of the area around the turn of the century.

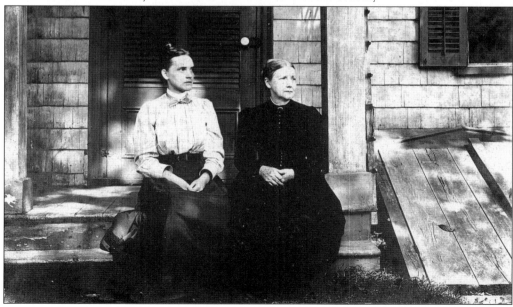

Forrest B. Randall built this home on the south side of North Country Road, west of Mount Sinai-Coram Road, in 1904, when he married Achsa Warner, a schoolteacher from Miller Place. As his family grew, Forrest's farm also prospered. He planted a large apple orchard and sold the fruit and other farm produce. Originally known as Arrowhead Farm because of the hundreds of Native American arrowheads Forrest unearthed while plowing, the 75-acre property was incorporated as Randall Farms in 1942. A milk license was purchased, and the Randalls began to operate a dairy farm and milk plant during the 1940s.

This barn was constructed on the Randall farm in 1889. Chestnut trees were hand-cut for the massive beams, measuring 10 inches square and 40 feet long, that were used in the construction of the barn. Wagonloads of hay could be driven into the barn and stacked into the haymow. Stalls in the basement housed cows and horses. Forrest loaded his wagon and peddled milk, butter, and eggs in the nearby village of Port Jefferson to support his widowed mother and siblings. Family members recall that in 1900, Forrest planted a five-acre crop of pumpkins, shipped them to Connecticut in barrels by ferry, and made a fine profit. Neighbors followed suit the following year, but lost money because the market was flooded.

Two

HAMLET ON
THE HARBOR

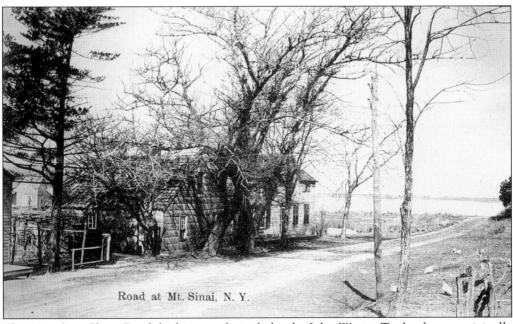

Road at Mt. Sinai, N. Y.

This view from Shore Road, looking north, includes the John Waters Tooker house, originally built in the 1700s. A new house was built *c.* 1830. It was attached to the older structure by a hallway, and the original structure was torn down sometime in the 1900s. John Hutchinson ran a general store at this location, which was continued by his son-in-law, Selah Tooker, into the 1900s. This postcard dates from *c.* 1910.

This 1901 view of the Tooker barn was taken looking toward the harbor. Shore Road runs along the right side of the photograph. Note the chickens crossing the road towards the center of the photograph, which was taken by William R.P. Van Pelt in 1899. This building housed a general store run by Selah Tooker.

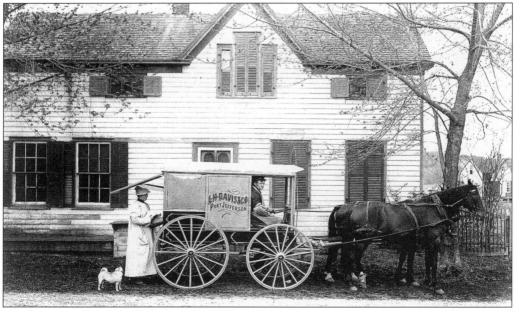

This home, parts of which date to the 1700s, is located on the northwest corner of Shore Road as it turns alongside the harbor. Selah and Clarinda Tooker, descendants of the family, lived here *c.* 1900. This photograph identifies William R.P. Van Pelt's wife, Mary, making a purchase from Lester H. Davis's wagon. Davis's business was located in Port Jefferson, but he would travel to local villages peddling his wares.

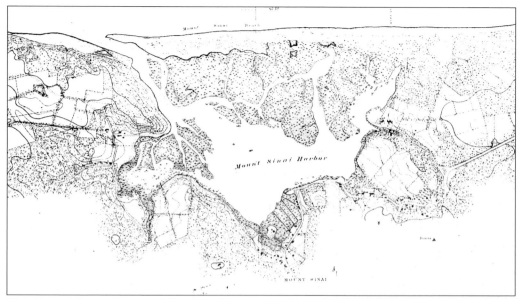

This United States Coast and Geodetic Survey map shows the North Shore from Mount Misery in Port Jefferson to Rocky Point Landing, which was surveyed in 1885. The extensive wetland areas within Mount Sinai harbor are clearly visible here, before dredging significantly altered the harbor. The channel to Long Island Sound can be seen on the western side of the harbor on this map.

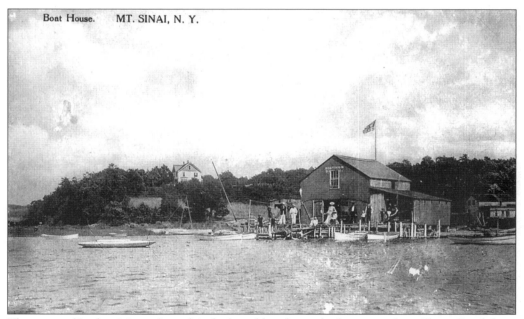

This view of Luther Minor Satterly's dock and boathouse looking west from Shore Road dates from the early 1900s. Brookhaven issued permits to build the dock over the marsh in 1888. By 1901, Satterly was renting boats and had changing rooms available for bathers. Satterly's Landing catered to summer tourists who visited Mount Sinai from the New York City area.

31

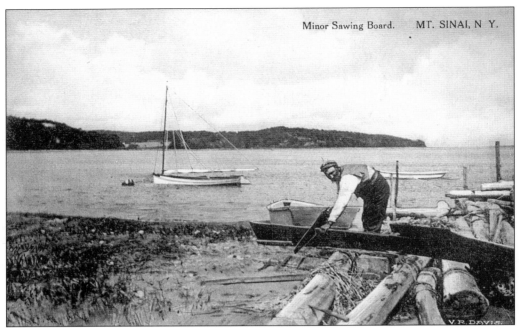

Minor Sawing Board. MT. SINAI, N.Y.

Here, L. Minor Satterly is sawing a board at the harbor *c.* 1900. Satterly ran a store at his boathouse, where he sold food and soft drinks to Mount Sinai visitors. Vincent R. Davis, who served as the Mount Sinai postmaster from 1907 to 1916, sold these postcards as advertising for his shoe store.

This view of the dock at Satterly's Landing taken from the harbor in the early 1900s offers a view of the cornfield known as Hall's lot to the right. Satterly, who ran the boathouse at this location until his death in 1916, is pictured standing on the left behind the group fishing off the dock. In 1920, the property was renovated, and it reopened in 1923 as the Harbor Inn. George Platford bought the property later in the 1920s. Ralph and Barbara Davenport purchased it in 1961.

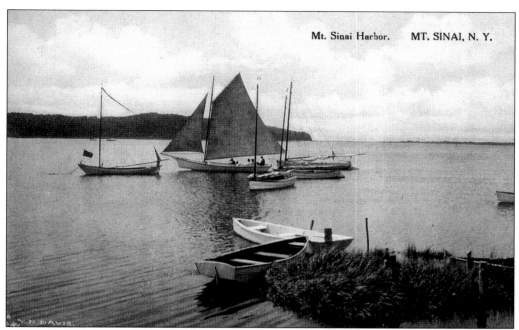

Sailing, fishing, swimming, and other water activities kept visitors to Mount Sinai busy during the long summer months. Many summer residents came out from New York City to enjoy the beautiful natural surroundings found along the harbor. Poulson's , seen below, was built along Shore Road to control tidal flooding sometime after 1910, when automobile traffic increased along the harbor road.

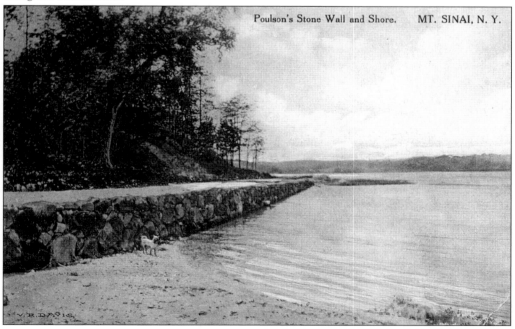

Poulson's Stone Wall and Shore. MT. SINAI, N. Y.

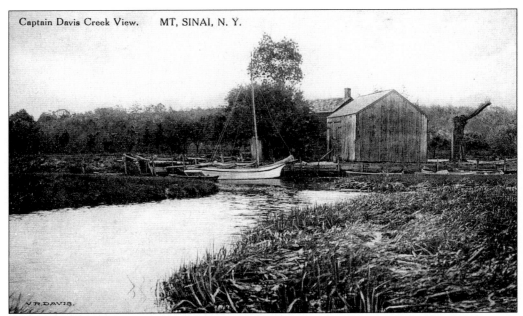

Captain Davis Creek View. MT, SINAI, N. Y.

This postcard of the creek leading to the Davis boatyard dates from the early 1900s. In the early 19th century, Capt. Daniel Davis developed a piece of his property into a summer vacation spot for visitors to Mount Sinai. A causeway was constructed connecting the property to the mainland in 1860. Debris from the demolition of the Jefferson Hotel in Port Jefferson was used, and bricks can still be found under the roadway. Rowboat rentals, swimming facilities, a casino, and a dance pavilion were available on the island. During World War I, Camp Upton soldiers would attend dances held here. By the 1950s, Davis Island became a storage facility for boats. Owner Robert Zumpf moved the boatyard across the harbor, at the request of the town of Brookhaven during the 1970s, where it operates as Old Man's Boatyard.

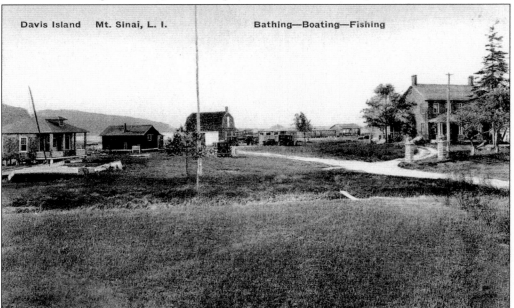

Davis Island Mt. Sinai, L. I. Bathing—Boating—Fishing

Mount Sinai resident and fisherman Augustus C. Tooker caught a very large turtle "while spearing flounders in the channel at low tide" on August 20, 1901. According to newspaper accounts of the event, great excitement ensued in the town as friends and neighbors stopped by his home to view the live turtle and congratulate Tooker on his unusual catch. The turtle weighed nearly 65 pounds and measured a foot and a half wide and two feet long.

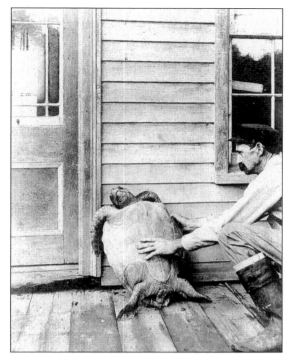

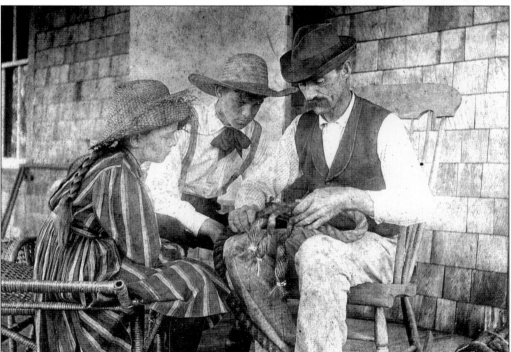

Fisherman Gus Tooker shows local children the intricacies of rope work in this *c.* 1900 photograph. The Tooker family purchased one of the first lots of land sold by the town of Brookhaven in Mount Sinai in 1668.

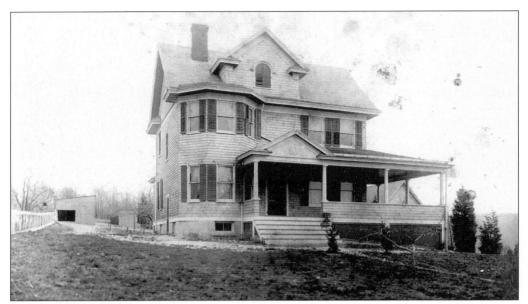

Eleanor C. Dickerson built this home in 1900 on the cliff now known as Eagles Landing overlooking Shore Road. Thomas Lynch, originally from Brooklyn, bought the house in 1905. In 1924, his daughter sold the home to Lillian Owens, sister-in-law of John C. Sheridan, who owned the home next door. Below is a picture of the back of the Sheridan home, which was known as Cedar Cliff. Extensive archeological excavations were conducted prior to the construction of new homes near here during the 1990s.

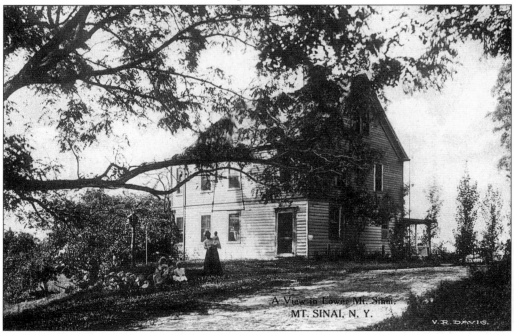

A View in Lower Mt. Sinai.
MT. SINAI, N. Y.

V. R. DAVIS.

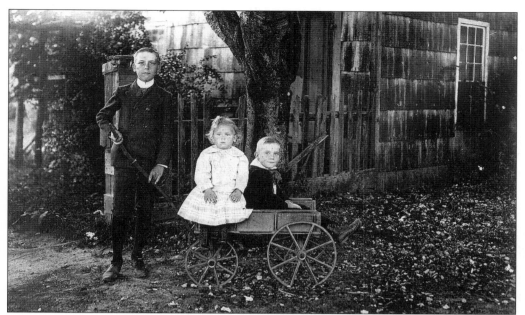

Mount Sinai residents Arthur, Alfred, and Raymond Carr are pictured in front of Gus Tooker's house *c.* 1900. Mount Sinai was a popular vacation retreat during the early years of the 20th century. Several large homes with landscaped lawns and gardens were built around this time. By 1914, however, the building boom had ended. Below is a photograph, likely taken by Brooklyn photographer William Van Pelt, showing local children out for a horse and buggy ride in front of Tooker's. Residents recall that Van Pelt often posed local children for photographs while working in the area.

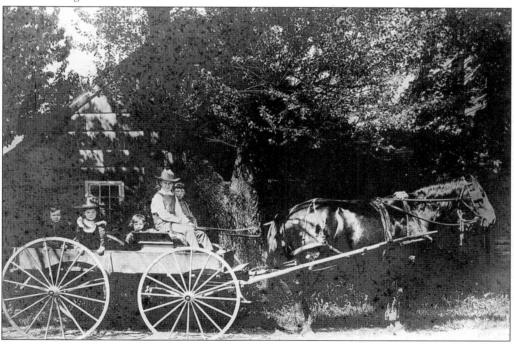

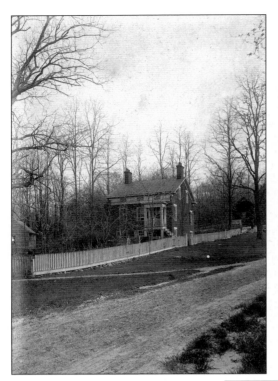

The Capt. Elisha Norton house on the south side of Shore Road and west of Mount Sinai-Coram Road, c. 1810, is pictured here in 1899. Built for Elias Norton, it was the first brick house in the area. Sea captain Elisha Norton purchased the home c. 1843. Havens J. and Fannie T. Davis purchased it in 1899, and Fannie used it as a boardinghouse. In 1902, a separate building providing eight bedrooms was erected to accommodate more boarders. The building was converted to a one-family bungalow in 1910, and in 1931, Havens J. and Fannie T. Davis gave the house to their grandson Charles T. Davis and his bride, Beatrice L. Burke, as a wedding present.

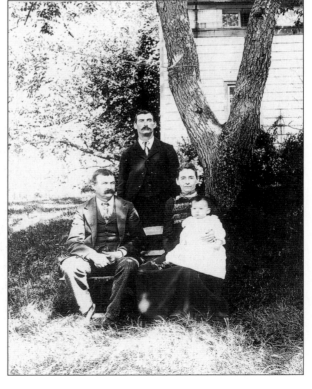

This photograph of the Davis family was taken c. 1900. Pictured here are, from left to right, Havens Jones Davis, Lorenzo H. Davis (Havens's son), Fannie Tuthill Hopkins Davis (Havens's wife), and William Van Pelt Davis (Havens's son). William's middle name was given to him in honor of Mount Sinai neighbor and family friend, photographer William R.P. Van Pelt.

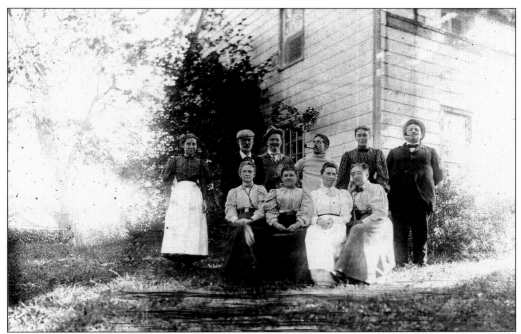

This house was built sometime before 1800 off of Shore Road, behind the Capt. Elisha Norton home. In the 1890s, Havens J. and Fannie T. Davis rented the house. Fannie ran a boardinghouse here and is pictured with some of her boarders. In 1929, Dr. and Mrs. Blamey bought the property and tore the house down, leaving only the foundation. The Blameys added several other buildings and built the first known in-ground cement swimming pool in the area.

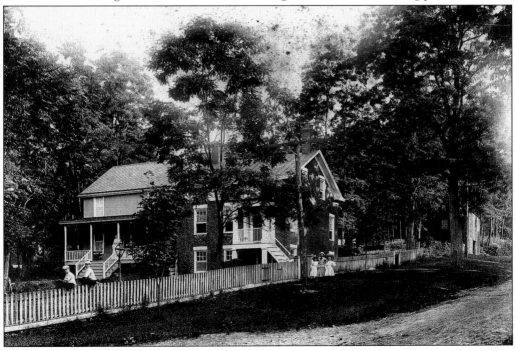

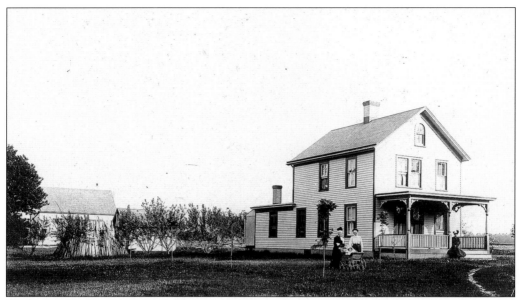

The James W. Davis house was built in 1898 and is located on the south side of North Country Road next to the present entrance to the high school at Gertrude Goodman Drive. The barn in the background is still used by the Mount Sinai school district. Pictured in front of the house, from left to right, are Letitia Rowell, her grandson James Rowell Davis, and her daughter, Eliza Rowell Davis *c.* 1901. James Rowell Davis worked as a mechanic and car dealer.

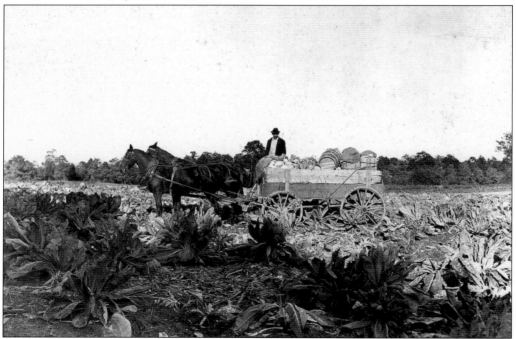

James W. Davis is pictured in the field with a horse and wagon *c.* 1904. James Davis farmed with his brother Lorenzo H. Davis in this area in the early 1900s. Cousin William Van Pelt Davis, who eventually inherited this farm, is standing between the horse and wagon.

Photographer and Mount Sinai summer resident William Van Pelt took this 1903 picture of a horse-powered threshing machine at Joseph Kempster's barn. The horse walked on the inclined treadmill to power the machine used to thresh the grain inside the barn. Samuel Hopkins, a Miller Place resident, owned the machine.

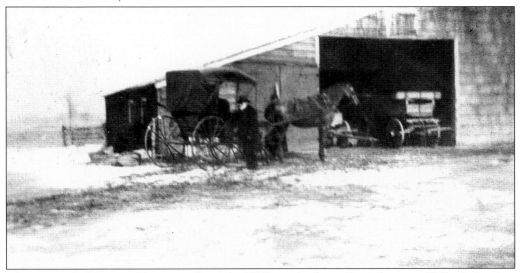

This view of a horse and buggy in front the William Amherst Davis barn on Hallock Avenue dates from c. 1900. The 180-acre farm was in operation from the late 1800s until it was sold for development as the Ranches in the 1990s. Daniel Woodhull, William Amherst's father, built a brick home on Shore Road in the late 1800s. He would take a team of horses across North Country Road, down Birch Hill Drive, and across Hallock Avenue, onto the flats to cut cordwood. William's son Amherst, who later ran the farm, built a home on the flats during the 1920s. During this time, the farm grew vegetables for sale and had two cow barns where 65 Holsteins produced milk.

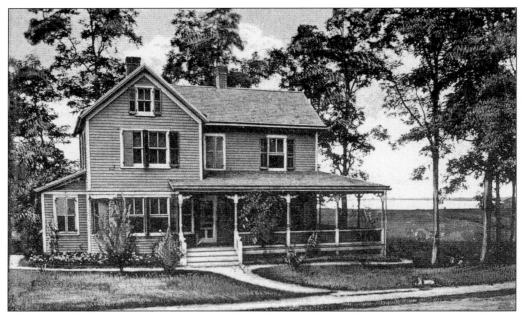

This is a postcard of the cottage owned by George T. and Maggie Dellar, located on the north side of Shore Road approaching the harbor. The house was built in the early 1800s. The Dellars, and later their daughter and son-in-law, used the house as a summer residence until the mid-1900s, when it was converted to a year-round dwelling.

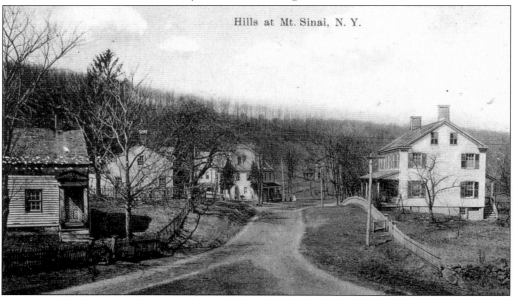

Hills at Mt. Sinai, N. Y.

This 1908 postcard offers a view of Old Post Road, with the Timothy Norton house on the right and the Theodore Velsor Davis home on the left. Davis's brother, sea captain John Wells Davis, lived in the next house on the left. Seafaring men, John Wells and his son, John Elbert, drowned while on a sea voyage. Willoski, Davis's other son, went down on the *CC Colgate* in 1869. The third home on the left is the Homan house, which later became part of the Poor Clares of Reparation Episcopal convent.

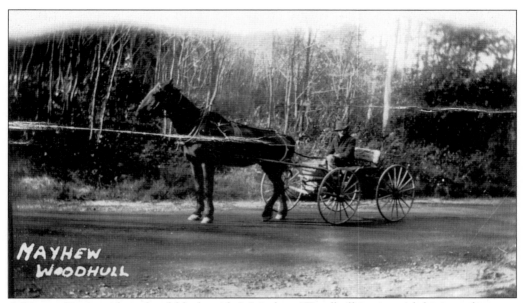

A Mount Sinai resident, local blacksmith J. Mayhew Woodhull is pictured driving a buggy *c.* 1900. Local residents recall that Woodhull would offer to cut a neighbor's grass and would have his horse graze the property instead. When his home was lost to a fire in 1915, the local community raised money to build a new house for him on Shore Road.

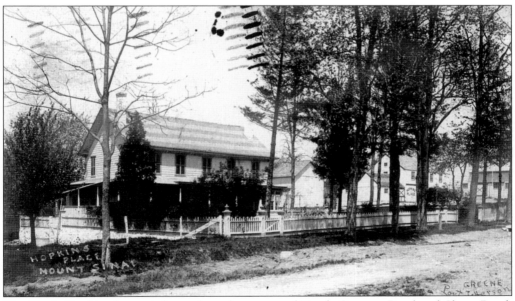

The Davis-Hopkins house is located on the corner of North Country Road and Shore Road, next to the Mount Sinai Congregational Church. Samuel Hopkins built this home in the early 19th century, replacing an earlier 18th century house on the site. James H. Hopkins, the grandson of Samuel, inherited the house from his mother, Mary Tuthill Hopkins. The Hopkins family first settled in the Mount Sinai-Miller Place area in the 1700s and bought this property at a mortgage sale in 1838.

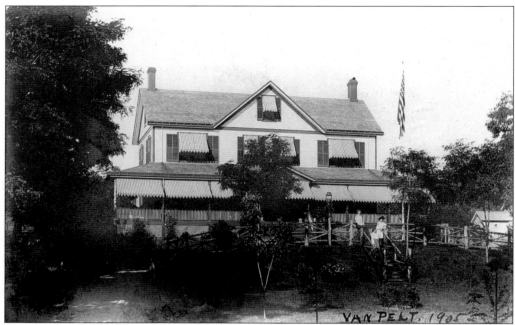

Photographer William R.P. Van Pelt was a summer visitor to Mount Sinai for nearly 20 years before he finally built his own home on the south side of Shore Road, west of Old Post Road, c. 1900. Originally built as a summer home, the house was eventually converted to a year-round home. A barn and the gazebo seen in the photograph below were later added to the property. Van Pelt took many pictures of local buildings and people during his time in Mount Sinai. Many of his photographs survive in the collections of local families whose roots go back to the early 20th century. The Van Pelts sold the home in 1912.

William Van Pelt's wife, Mary, is pictured bicycling by the harbor accompanied by a pugdog sometime *c.* 1900. The Van Pelts spent time in Mount Sinai for many years, first boarding at various homes in the area, and later in their own home on Shore Road.

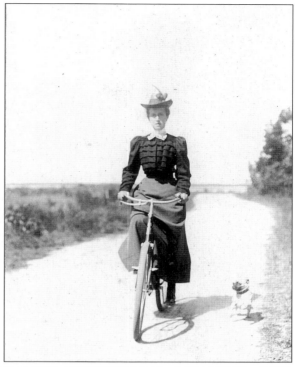

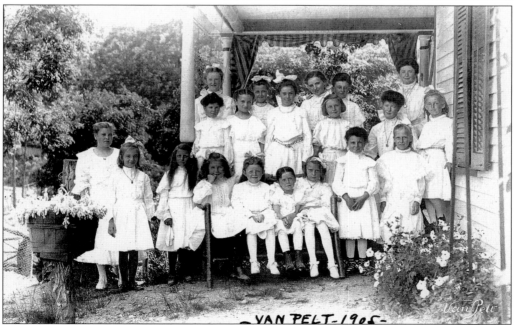

The Van Pelts enjoyed entertaining, and often gave parties in honor of their nieces, Mildred Hope and Annie P. Van Pelt, who were frequent visitors to Mount Sinai. Local girls would be invited to barn dances and extravagant parties at the Van Pelt home, where paper lanterns lit the grounds during the festivities.

This photograph of Gustave Brunjes and family dates from *c.* 1900. One of the many Brooklyn families who summered in Mount Sinai during the early 20th century, the Brunjes bought the John Wells Davis house on Old Post Road, originally built in the 1800s, and called it Lone Pine Cottage.

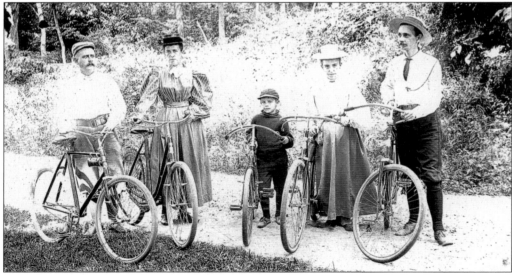

William and Mary Van Pelt, a young Cabble boy, and Alonzo and Lucy Dellar Carr are pictured bicycling in Mount Sinai. Summer residents took advantage of the many recreational activities available in Mount Sinai, which included bicycling, boating, swimming, fishing, and more.

Three

PLAYGROUND OF

NEW YORK

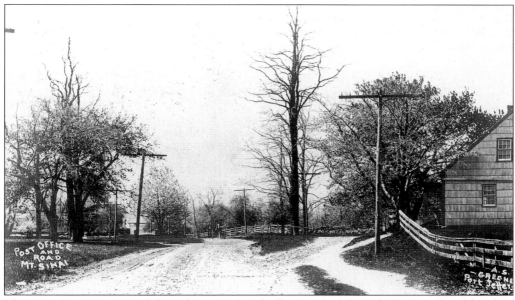

This A.S. Greene postcard dates from 1907 and offers a view of North Country Road heading west in front of what was the post office at the Phillips-Randall house. The poles running along North Country Road indicated that some telephone service had come to Mount Sinai, but the narrow country road was still unpaved. The post office had one of the first telephones, along with some local businesses. Some of the wealthier residents had electricity by the 1920s, including Brookhaven town trustee Henry Silverman and Robert Griffiths.

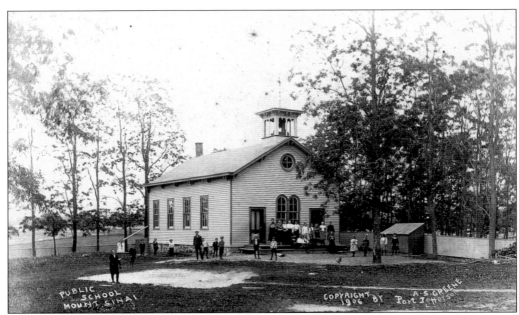

A.S. Greene photographed the one-room schoolhouse at Mount Sinai sometime before 1908. The school district purchased a one-half-acre plot of land from Charles and Maria Phillips in 1869 for between $1,200 and $1,500. Funds to build the school building totaling $1,800 were borrowed from Daniel Woodhull Davis, who was serving as trustee at this time. Below is a 1906 photograph taken by Greene outside the Mount Sinai school building. Guiletta Hutchinson, whose father was a local sea captain, was the teacher in the one-room schoolhouse. Pictured from left to right are as follows: (front row) unidentified, Amherst Davis, Clarence Wells, William Van Pelt Davis, Sid Petty, Hallie Kempster, Blanche Brown, Edyth Roys, Maddie Homan and ? Goss; (middle row) Leon Kempster, Earle Kempster, Henry Goss, Helen Kempster, Florence Roys, Carolyn Mott, unidentified, and Clara M. Smith; (back row) Dick Goss, Rob Wheeler, Guiletta Hutchinson, Grace Kempster, Mildred Hope, Lulu Goss, Estelle Petty, and Bertha Petty.

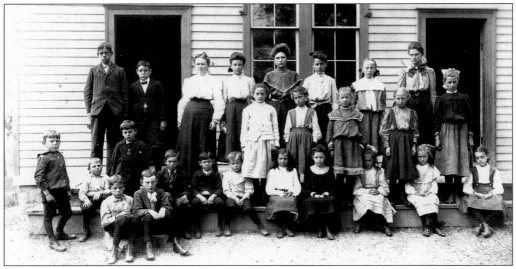

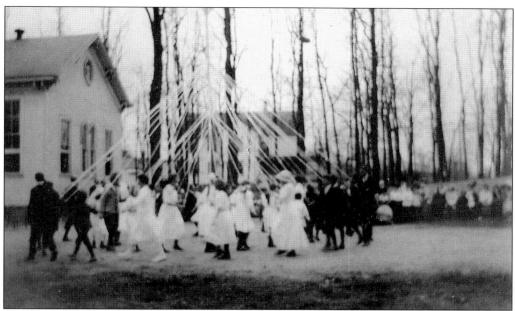

Mount Sinai school students celebrated May Day with a traditional dance around the Maypole. The addition put onto the Mount Sinai school between August and October 1908 at a cost of $1,400 can be seen below. The front of the building was extended to create an additional classroom, and the existing windows were reused on the new section. The Port Jefferson school district provided high school education for Mount Sinai students beginning in 1890. Prior to that time, students traveled to Huntington. The district stopped using this building after 1958, and all the students were educated at Port Jefferson until the completion of a new elementary school in 1966. The state department of education required the addition of a gym and cafeteria. With no money to expand, the district auctioned off the building, and it was dismantled for lumber in 1961 or 1962. The firehouse was built on this site in 1963, and the original school bell is still housed there.

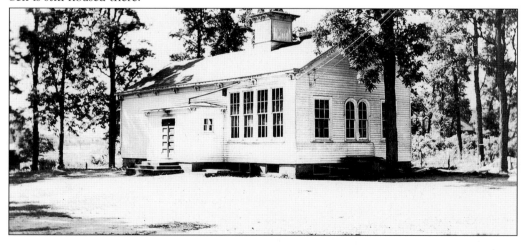

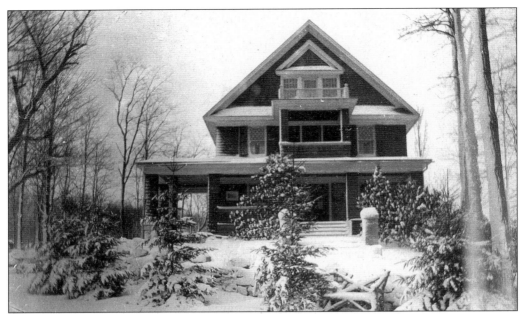

The Ludwig A. Goebel family sent this beautiful winter view of their home on Shore Road as a Christmas card *c.* 1910. Goebel was an upholsterer from Brooklyn and an avid hunter. After spending summers and hunting seasons here as a boarder, he built a permanent home called the Anchorage in Mount Sinai in 1905. The dwelling, which replaced an 18th-century building, was located on the south side of Shore Road. He moved his business to Mount Sinai and provided upholstery for wealthy boat owners up and down the East Coast. A children's camp called the Mount Sinai Athletic Club was run at the Goebel Estate beginning in 1907 and sponsored a dramatic club as well as team sports, diving, swimming, rowing, and sailing. Below is a photograph of Goebel with his family and boarders.

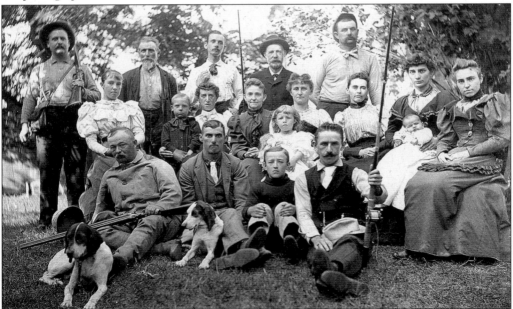

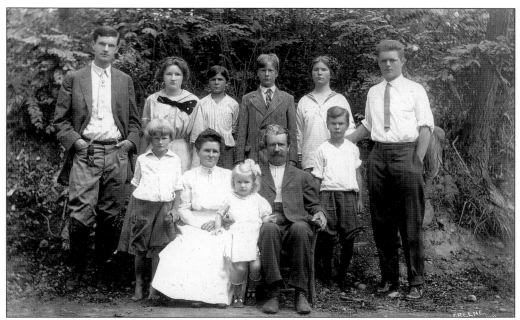

A.S. Greene took this photograph of Thomas and Augusta Murphy and their children in the early 1900s. Local folklore has it that noted environmentalist Robert Cushman Murphy (pictured on the left in the back row) developed his interest in science as a young boy exploring the flora and fauna in and around Mount Sinai Harbor. Murphy later worked to protect Mount Sinai Harbor by speaking out against the dredging operations, which threatened to destroy the environmental balance of the wetland areas. He was later the director of the American Museum of Natural History in Manhattan.

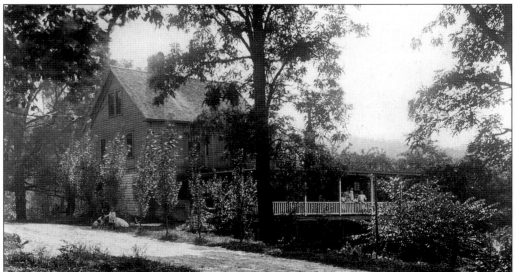

Thomas D. Murphy, a school principal from Brooklyn, purchased the Thomas Bayles home on Shore Road in 1896. He summered in Mount Sinai with his wife Augusta and their nine children for many years and eventually lived there year-round. Parts of the home, located on the west side of Shore Road, north of Old Post Road, date to the late 1600s or early 1700s.

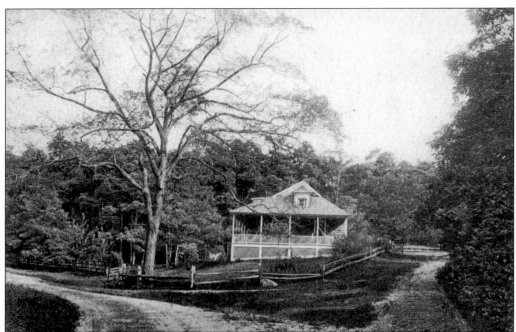

Pictured below *c.* 1900 with his wife, Blandina, and three children, is summer resident lawyer Frank D. Arthur of Brooklyn. Their home, originally built in the 1700s, was on the corner of Shore and Rocky Hill Roads on Mount Sinai Harbor. The Arthurs sold the house pictured above in 1915. The October 12, 1930 fire that destroyed this house, then owned by Dr. and Mrs. Frank Skinner of Brooklyn, motivated local residents to establish the Mount Sinai Fire District.

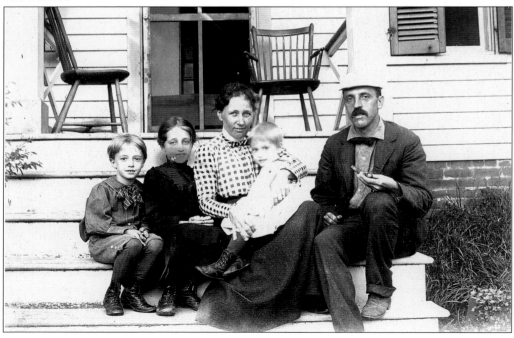

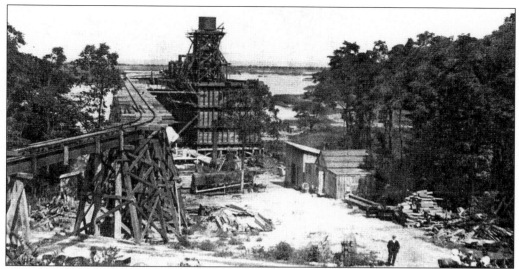

This picture depicts the Brookhaven Sand and Gravel Company refining plant in 1910, which was constructed by the company at the east end of Mount Sinai Harbor on Shore Road. The company applied for a permit to build a sand and gravel refining plant as part of a planned housing development, but apparently its real purpose was a full-scale mining operation. According to local residents, the trestle and train constructed to facilitate sand-mining directly across Shore Road from the Arthur home in 1910 was only used for one day, then mysteriously burned to the ground.

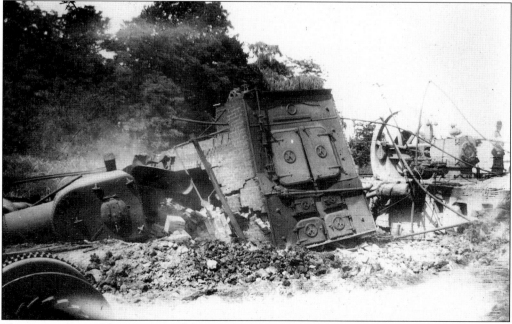

The train pictured here was used by another operation on Long Island, and the trestle was finally torn down in 1917. Local residents fought hard to stop the dredging of the harbor, and the Mount Sinai Civic Association was founded as a result of opposition to the dredging of the harbor and the surrounding hills.

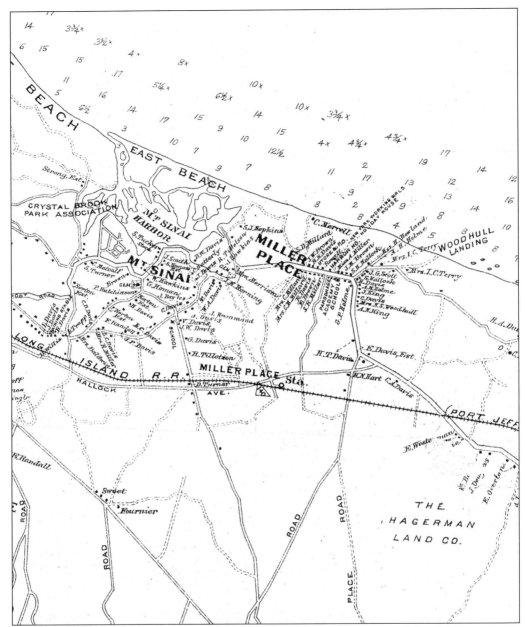

This atlas of the North Shore of Suffolk County, published by E. Belcher Hyde in 1906, illustrates the route the Long Island Rail Road took through Mount Sinai. The Long Island Rail Road's Port Jefferson branch originally continued east through Mount Sinai to Wading River, with stations at Miller Place and Shoreham. The line ran along what is now the Long Island Power Authority right of way north of Route 25A, then known as Hallock Avenue. The tracks are clearly marked on this map. The line was closed in 1939, when railroad service terminated at Port Jefferson. (Courtesy the Department of Special Collections, Stony Brook University.)

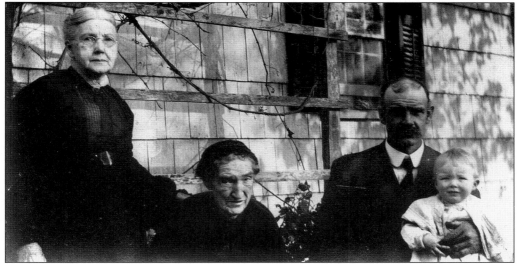

Eliza Catherine Randall, her "Aunty" Tuthill, and Forrest B. Randall with his son John are pictured in front of the Phillips-Randall house on North Country Road. The photograph was taken on November 6, 1910. Family members recall the story of how Forrest dropped his wife, Achsa, off to visit her father in Miller Place one night, then met with the board of trustees at the Mount Sinai Congregational Church. After a heated meeting, Forrest went home, went to bed, and did not realize he had left his wife in Miller Place all night, until he missed her at breakfast at 8:00 a.m. the next morning.

In this 1914 photograph, Fannie Tooker Davis is pictured with her son, William Van Pelt Davis, and grandson Charles Tooker Davis. Fannie's son, Lorenzo H. Davis, was Charles's father. The Davises raised Charles after their daughter-in-law Edna Limella Randall Davis died in childbirth after giving birth by forceps delivery. Lorenzo remarried in 1919, but Charles remained with his grandparents. Lorenzo H. Davis ran a stagecoach service from Port Jefferson to Mount Sinai. He also rented horses and buggies from a barn on Mount Sinai-Coram Road near Shore Road during the early years of the 20th century.

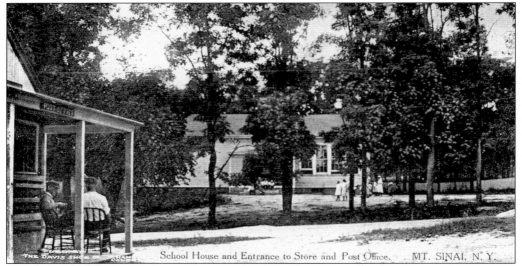

School House and Entrance to Store and Post Office. MT. SINAI, N. Y.

This hand-colored postcard offers a 1913 view of the entrance to the store and post office at Vincent R. Davis's on Mount Sinai-Coram Road. The schoolhouse and yard may be seen in the background. Vincent R. Davis was appointed postmaster in 1907. Victor Floyd Davis took over the post office and store from Vincent, who died in 1916. He ran the business at this location until 1922, when he relocated to the east side of Mount Sinai-Coram Road, south of North Country Road. Davis retired in 1923, and his nephew Mark H. Davis became postmaster at the new location.

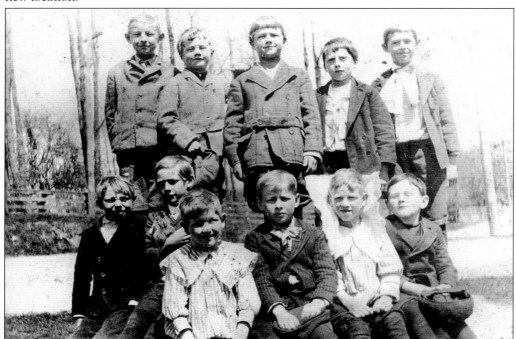

Pictured in this c. 1915 photograph, from left to right, are as follows: (front row) Earle Kempster, Frank Woodfield, Arthur Tripp, William Sidney Petty, and Ed Tripp; (back row) Ernest Goebel, Charles Murphy, Tom Murphy, Lucien Hoglins, and James Rowell Davis.

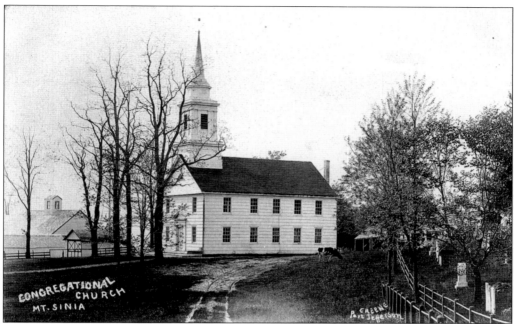

This A.S. Greene photograph view depicts the Mount Sinai Congregational Church *c.* 1906. George Hopkins's barns can be seen on the left, a carriage shed and grazing cows are seen on the right, and a hitching post is seen in front of the cemetery fence. The parish continued to grow and develop. In 1890, the Mount Sinai Congregational Church burial ground was transferred to the Sea View Cemetery Association. The church cemetery, originally established in 1841, incorporated as Seaview Cemetery in 1892. Below is a photograph taken of a Tom Thumb Wedding, celebrated sometime in the early 1900s. These social events were relatively common during this era, when children would dress up and perform mock weddings as part of pageants.

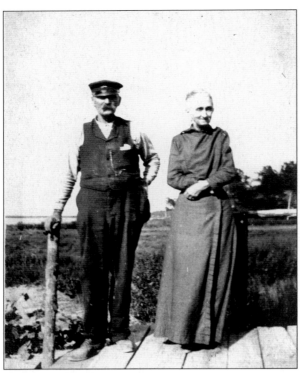

L. Minor Satterly and his wife, Charlotte Ketcham Hawkins, are pictured at their dock in September 1914. Satterly's Landing continued in operation until George Platford bought the property in the 1920s. By the middle of the 20th century, dredging had resulted in major changes to the harbor environment.

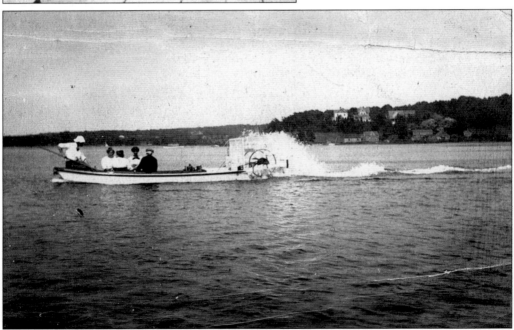

A steam-powered paddleboat cruises on Mount Sinai Harbor *c.* 1910. Pictured at the far left of the photograph are the Tooker and Satterly houses. In the background, on what is now known as Eagle's Landing, the Lynch-Owens home is seen on the right, and the Sheridan home is seen on the left. The Tooker house is to the right of the photograph.

John and Laura Remsen owned the house pictured on the left of this 1913 postcard during the middle of the 20th century. Jeremiah Kinner, one of the founding members of the Mount Sinai Congregational Church, originally built the home, located where Shore Road turns left at the harbor, *c.* 1800. The Eaton family purchased it sometime in the early 19th century. In 1903, James C. Hendricksen bought the property, sight unseen. His daughter and son-in-law, Anna and Garret Remsen, inherited the house. John and Laura Remsen eventually moved permanently to the house in the 1940s. The Hendricksens and Remsens were from old Dutch families in Brooklyn. John Remsen was one of the founders and long-time secretary of the Mount Sinai Civic Association and worked to protect the harbor environment. Below is a view of Shore Road with the Remsen home on the right.

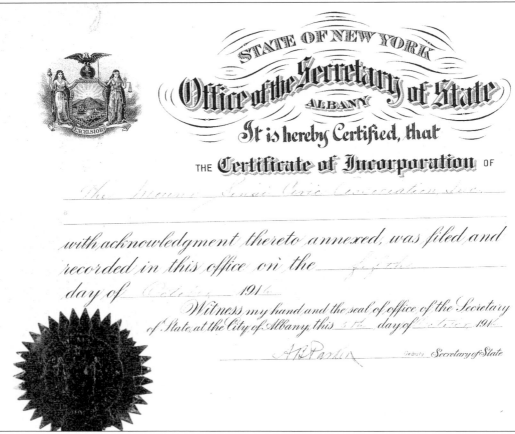

STATE OF NEW YORK

Office of the Secretary of State

ALBANY

It is hereby Certified, that

THE **Certificate of Incorporation** OF

The Mount Sinai Civic Association, Inc.

with acknowledgment thereto annexed, was filed and recorded in this office on the _fifth_ day of _October_ 1916

Witness my hand and the seal of office of the Secretary of State, at the City of Albany, this _5th_ day of _October_ 1916

A.B. Parker Deputy _Secretary of State_

This certificate of incorporation was awarded to the Mount Sinai Civic Association on October 5, 1916. Wealthy summer residents from New York City formed the association to oppose the dredging of Mount Sinai Harbor. Continuously active since 1916, the association is dedicated to protecting the character and quality of life of Mount Sinai residents. Laura Remsen, wife of one of the founders, discovered the charter in her home while preparing to move and gave this important document to the civic association in the 1980s.

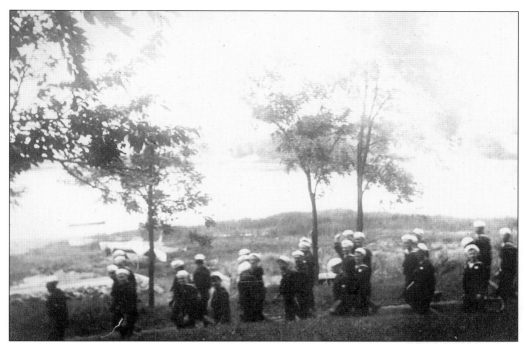

John Remsen took these photographs of World War I sailors during fleet exercises held in 1917. Sailors landed on the beach at Rocky Point, east of Mount Sinai, and had to march along Shore Road to meet their ships at Port Jefferson Harbor.

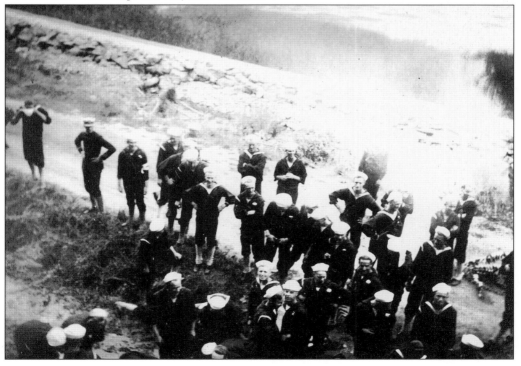

Stage actor Lionel Barrymore purchased a home, Restful Nook, in Mount Sinai in 1921 from playwright Mark Swan. The house was built into the cliff on Shore Road across from Mount Sinai Harbor. The home was originally built for James and Eliza A. Palmer in 1893. It is depicted here as it looked in 1909. Barrymore expressed interest in purchasing the Tillotson house on North Country Road *c.* 1910, but he withdrew his bid on the dwelling. Barrymore wrote to his caretaker, Gus Tooker, from the New York City Radisson hotel, asking him to have the house ready for occupancy in May. Restful Nook burned to the ground on December 18, 1986 in a spectacular fire on a windy day. The postcard below is entitled "View of the Harbor from a Restful Nook."

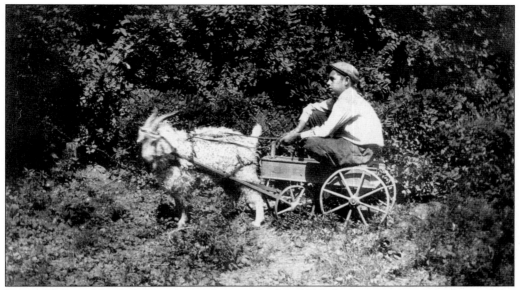

Young William Van Pelt Davis was photographed *c.* 1908 driving a goat cart in front of the Capt. Elisha Norton-Havens J. Davis home. James Rowell Davis is shown below with a chicken on a miniature dogcart *c.* 1914.

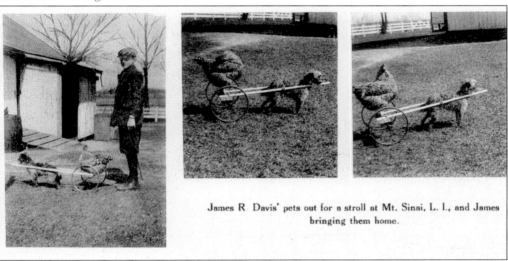

James R. Davis' pets out for a stroll at Mt. Sinai, L. I., and James bringing them home.

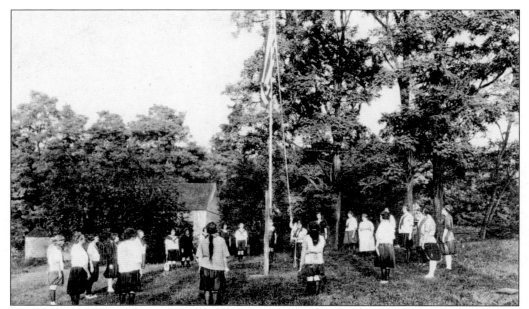

The YWCA (Young Women's Christian Association) Camp Monowatuck was established at what had been the John Henry Smith Hotel on Shore Road in Mount Sinai in 1923. This hotel was located on the site of one of the earliest dwellings in Mount Sinai, built by the Mogers in the 1600s. The name was a word play on the original Native American name for the area, *Nonowantuck,* meaning "a creek that dries up."

Camp Monowatuck was a popular summer destination for young women until it closed after Word War II. The harborside camp offered summer recreational activities for school-aged girls and young working women. Activities included boating, swimming, and camping. The Miller Place-Mount Sinai Historical Society has a Monowatuck camp songbook dating from 1922 among its collections. Mount Sinai was home to a series of children's camps throughout the 20th century.

Four

BEAUTIFUL
MOUNT SINAI

Claude Crookston, later Father Joseph, founded the Order of Poor Brethren of St. Francis in 1919 as an outgrowth of the Franciscan Revival in the Anglican Church. Father Joseph moved his religious community to Little Portion Monastery in Mount Sinai in 1928, where the community established itself on a 27-acre parcel of land donated by George Charles Metcalf Simms. Simms had inherited the land from his mother, Gertrude Metcalf Simms. This photograph depicts one of the two buildings on the property. Simms later joined the order and was known within the community as Father Stephen.

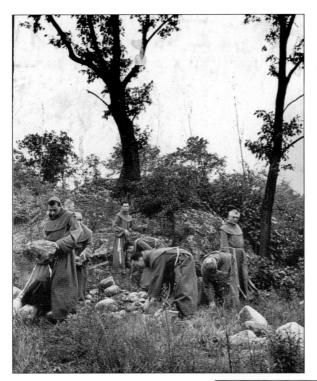

Much work had to be done to repair and develop the property to accommodate the monk community. The two buildings on the property were moved together to form a larger building suitable for communal living and use as a chapel. Monks worked as carpenters and masons, dug a well, blasted rocks, planted a garden, built an entrance road and fences, as well as cooked, cleaned, sewed, and maintained their religious observances.

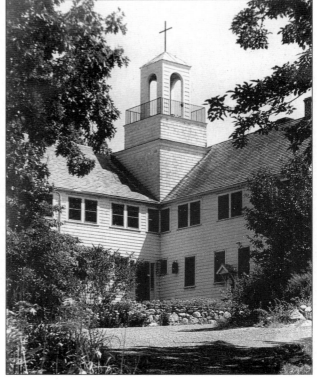

The Little Portion Monastery is shown here as it appeared during the 1930s, after the completion of additions and renovations made to the Simms property. Father Joseph also helped found the Order of Poor Clares of Reparation, a religious community for women, with Lily Dorset Gray, later Sister Mary Christine and first mother superior of the order. The Poor Clares moved into the coachman's cottage on the monastery property the fall of 1928. Father Joseph died at Little Portion Monastery on March 7, 1979.

John Platt Hutchinson was a sea captain who traveled all over the East Coast of the United States and into Central and South America. His house in Mount Sinai was built c. 1820 and was located on the north side of Shore Road at the intersection of Mount Sinai-Coram Road. Hutchinson married Charlotte Mulford, and took his daughter Guiletta, who later taught school in Mount Sinai, on voyages with him. William Mulch purchased the home in 1924.

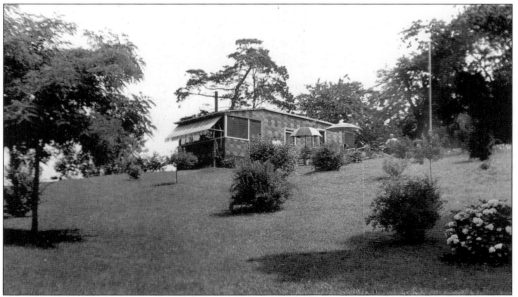

This cottage, built at the top of what was known as Hall's lot, near the harbor, was located on the south side of Shore Road on the sharp curve. Owned by a Fred Schermerhorn in the 1950s and 1960s, the original building was taken down, and a house with the lighthouse design was constructed in the 1970s by Finn Jensen.

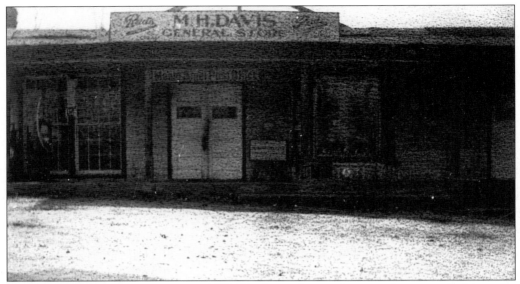

Mark H. Davis became postmaster in 1923. He also took over the general store run by his uncle, Victor Floyd Davis. Victor Floyd owned the Davis homestead property on North Country Road, as well as other parcels in Mount Sinai. He lost the homestead due to foreclosure in 1934.

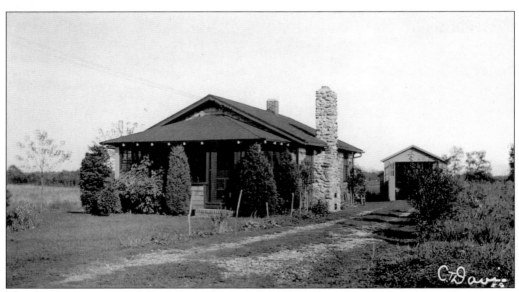

This building was moved from Camp Upton after World War I and is located on the east side of Shore Road. Charles T. Davis, Mount Sinai postmaster, took this photograph c. 1935.

The Post Office. Mt. Sinai, L. I.

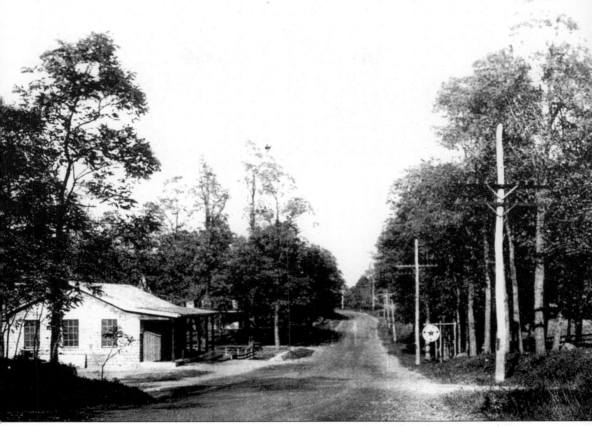

This postcard shows the post office on the left after it was relocated to the converted Camp Upton building on the northeast corner of North Country Road and Mount Sinai-Coram Road. Originally located at the World War I military camp in Yaphank, the building was purchased by Victor Davis, who moved it to the corner of his property when the government downsized its facilities after World War I. According to an article in the *Port Jefferson Echo,* 1,660 buildings were sold at auction in August 1922. The photograph was taken by R.S. Feather sometime after 1923, when North Country Road was still a narrow country lane. The view is looking east toward Miller Place.

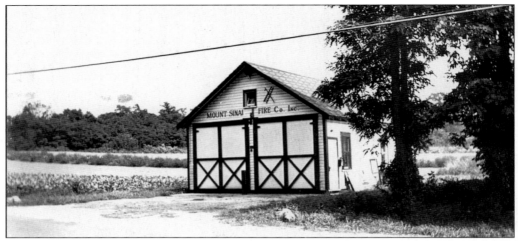

Mount Sinai's original firehouse was located on the south side of North Country Road, east of Mount Sinai-Coram Road. After the loss of a home on Shore Road, the community held a special meeting on the issue of fire safety, following the regular civic association meeting in October 1930, and a new fire department was formed. The fire district constructed this building on land owned by Harvey J. Kiefer of New York's Detective Bureau in January 1931. Kiefer and his wife gave the property to the fire company in 1943. Robert Griffiths, a wealthy Mount Sinai resident, donated $500 toward the construction of the firehouse. Oswald F. Coote was elected as the first chief, and the original board of directors included Amherst W. Davis, William A. Van Nostrand, Oswald F. Coote, Charles Rumenapp, and George Griffiths.

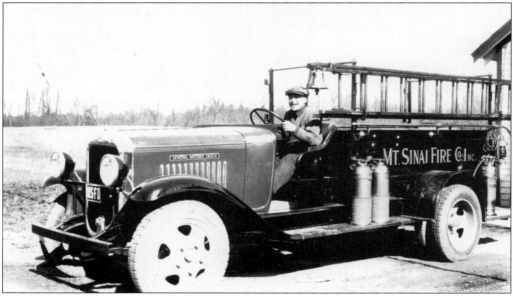

The Mount Sinai Fire Department invested in a new truck, which cost $600, in 1932, shown here being driven by Charles Rumenapp. The firemen used a second-hand truck purchased from Kings Park for $99 the first year the department operated. Fund raising events such as suppers, dances, and pledge drives paid for the new building and equipment needed to outfit the new fire department. A tax-supported fire district was formed in 1953 to fund the firehouse, trucks, equipment, and other necessary supplies.

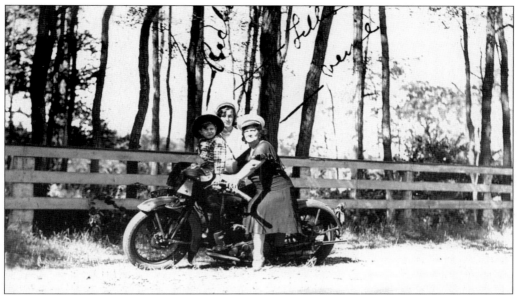

Lavinia Griffiths posed on the fire department's motorcycle with her grandson Richard Drewes on Labor Day, 1931, as Lillian Coote looked on. Below, Mount Sinai volunteer firemen assembled in front of the firehouse on North Country Road the same day. Pictured on the hook and ladder are, from left to right, Robert Griffiths, Robert C. Griffiths in his white summer uniform, and Honorary Chief George Griffiths. In the touring sedan are, from left to right, Chief Oswald F. Coote, Lillian Coote, and Lavinia Griffiths. Frank Woodfield is pictured on the motorcycle. By 1933, the company numbered 14 firefighters.

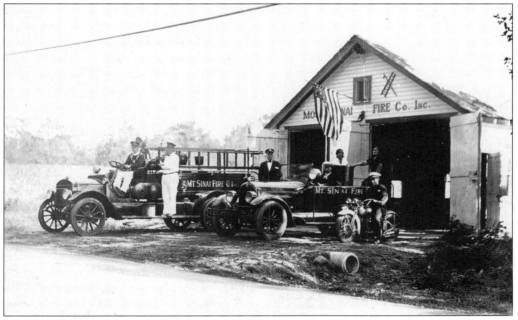

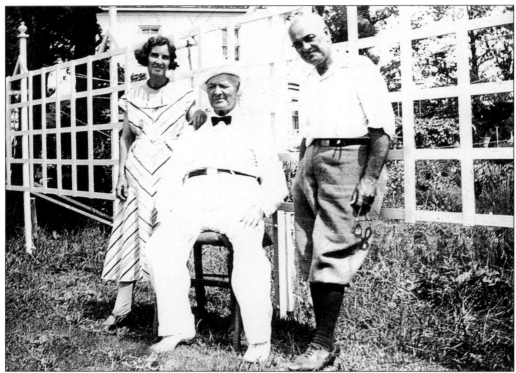

Robert Griffiths moved from Brooklyn to the small rural community of Mount Sinai, with a population of 150, in 1924. Griffiths was the head building contractor for the Metropolitan Opera House and made his fortune in real estate. He bought property on the north side of North Country Road originally owned by sea captain and farmer Joseph Colsh, who built the home in 1873. Griffiths modernized the home with indoor plumbing and electricity, added a back wing in 1925, and an enclosed porch in 1928. Various decorative enhancements, including the blue eagles that still grace the home, were also added to the house. Griffiths is pictured above at the age of 89, in 1935, with his daughter Eliza Jane and son George Edward.

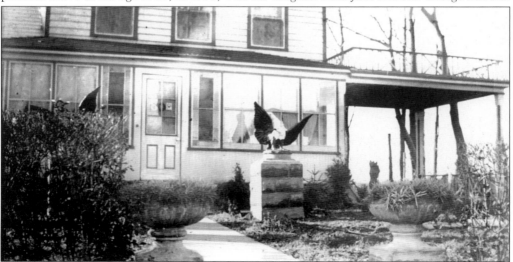

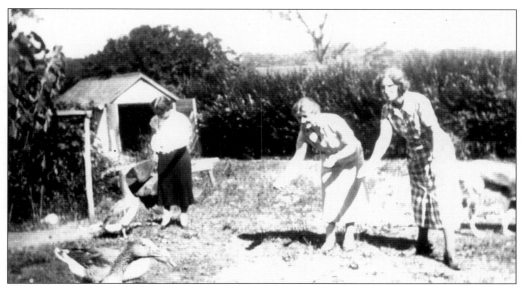

Robert Griffiths also purchased a poultry farm on the south side of North Country Road at the intersection of Mount Sinai-Coram Road. His son Robert C. Griffiths lived in this house and sold chickens, ducks, and geese, as well as eggs, during the 1930s. Pictured visiting the farm are, from left to right, Mrs. Fredericks, Gertrude Jaquard, and Eliza Jane Griffiths, Robert Griffiths's daughter. Below is a photograph of Eliza Jane Griffiths, Gertrude Jacquard, and Mrs. Fredericks while on a visit to Mount Sinai in the mid-1930s. This picture was also taken at the Robert C. Griffiths farm. New York City friends often enjoyed a summer day or weekend visit to the country.

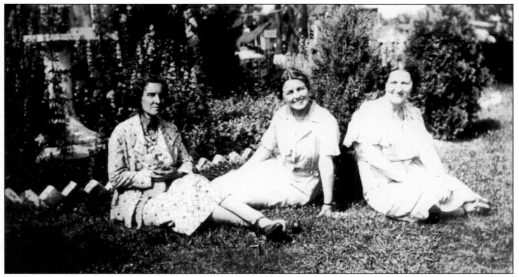

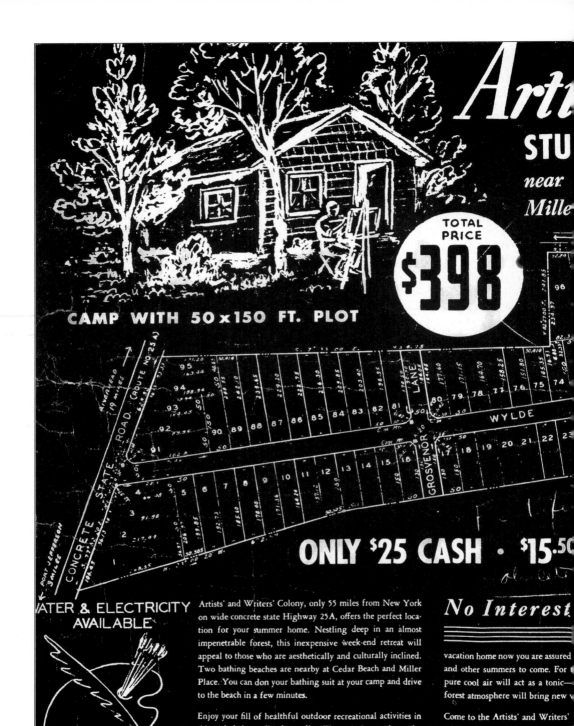

Although this map is labeled Miller Place, Carl "Jack" Heyser's Artists' and Writers' Colony was established during the 1930s in the hamlet of Mount Sinai. Local resident and carpenter Frank Sieger worked for Heyser, who advertised these "studio camps in the woods" as healthful and affordable summer retreats. Located just off Route 25A on Wylde and Pipe Stave Hollow

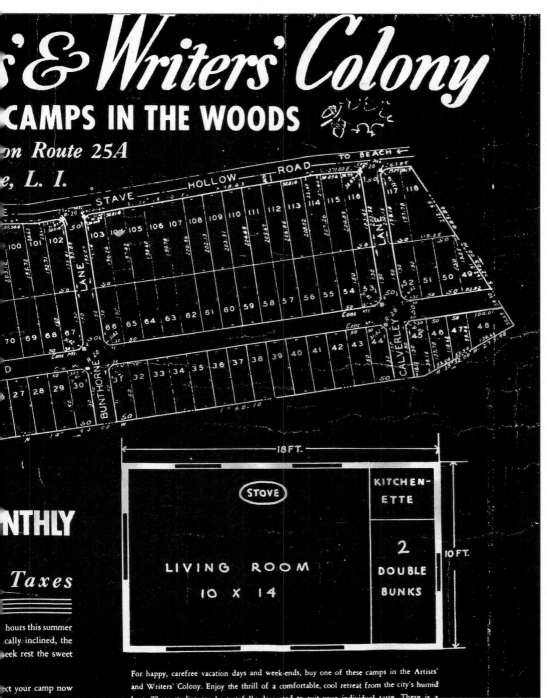

Roads, each 10-by-18-foot cottage on a 50-by-150-foot lot included a kitchenette, a small bedroom with two bunks, and a living room, but no bathroom. The terms of sale included a $25 down payment on the total price of $398, and a monthly cost of $15.50.

Local realtor James H. Hopkins advertised Mount Sinai as "the most beautiful spot on the wonderful North Shore." His home and office were located on North Country Road, west of the Mount Sinai Congregational Church. James was an active and well-known Mount Sinai realtor during the 1920s and 1930s. He also farmed and ran one of the early dairy farms in Mount Sinai.

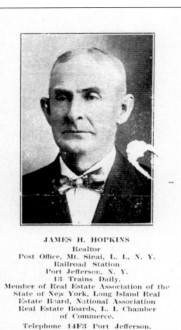

JAMES H. HOPKINS
Realtor
Post Office, Mt. Sinai, L. I., N. Y.
Railroad Station
Port Jefferson, N. Y.
13 Trains Daily.
Member of Real Estate Association of the
State of New York, Long Island Real
Estate Board, National Association
Real Estate Boards, L. I. Chamber
of Commerce.
Telephone 14F3 Port Jefferson.
Furnished Bungalows, Bungalow Sites.
Specialist in Suffolk County Land, Farm.
Mt. Sinai is one mile East of Port Jeffer-
son on the North Country Road. The
most beautiful spot on the
wonderful North Shore

Builder Carl "Jack" Heyser offered picturesque cabins in the woods for sale in Mount Sinai and Miller Place c. 1933. The summer colony of log cabins he built, known as the Cabins in the Woods, was the first residential housing development in the hamlet of Mount Sinai.

Captain Roman's Inn, originally used as the office for Carl Heyser's building development on Pipe Stave Hollow Road, was located at the corner of Pipe Stave Hollow and North Country Roads in Mount Sinai. Heyser's wife, Florence, ran a tearoom here until the 1940s. During the 1960s, a bar and restaurant operated in this building, which still existed in 2003 as Savino's Hideway Restaurant.

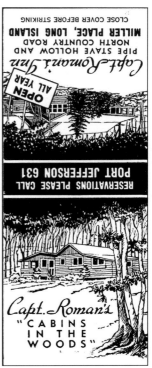

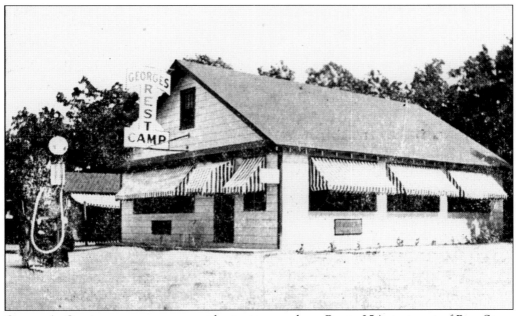

George A. Gutting ran a rest camp with picnic grounds on Route 25A, just west of Pipe Stave Hollow Road, during the 1920s, that catered to the new summer residents as well as day visitors. Note the gasoline pump in front of the building. Again, although the postcard indicates that the camp is in Miller Place, its actual location is Mount Sinai. This building was still a local restaurant called Eddie G's as of the year 2003.

This photograph of Forrest and Achsa Randall was taken during the 1930s at their home in Mount Sinai. Forrest inherited his father's farm at age 16 and ran it until 1959. He was a charter member of the Mount Sinai Fire Department when it was established in 1930, served on Mount Sinai's school board from 1895 to 1899, and was tax collector for School District No. 7 (Mount Sinai). Forrest also served as a trustee for both the Mount Sinai Congregational Church for many years and the Seaview Cemetery. Forrest died in 1964 at the age of 94.

Forrest and Achsa Randall had four children: Eloise, Grace, John, and Waldo. Grace died in 1910 at the age of two. Pictured are, from left to right, Eloise, cousin Charles T. Davis, Waldo, and John. Eloise was a schoolteacher in Huntington and commuted on the Long Island Rail Road. Charles was postmaster, then delivered milk for Randall Farms, and became a television repairman. John graduated from Cornell University in 1927 and began working the family farm. Waldo, who graduated from William and Mary, joined his brother in running the farm and dairy after working for the Grange League Federation, a farm cooperative.

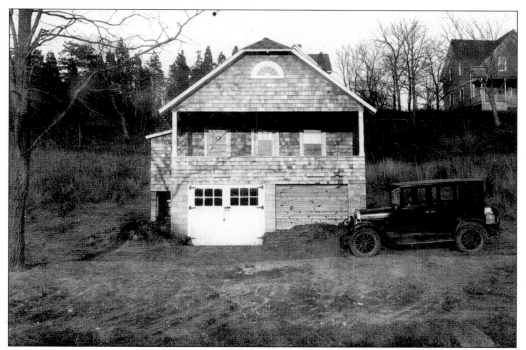

Mount Sinai resident and artist Gustav Scherzer lived with his family in this home, located on the east side of Shore Road across from the Selah Tooker home. The house was built in the 1920s on what was known as Hall's lot, a cornfield across the road from the harbor. Below, Scherzer is shown on the left in 1937 with the day's catch of 14 weakfish.

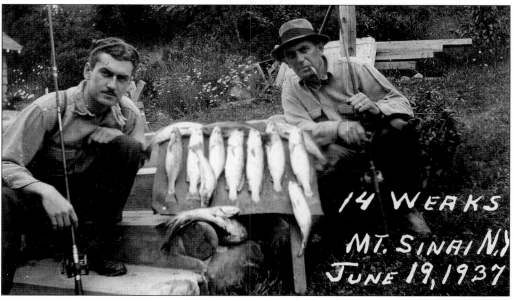

14 WEAKS
MT. SINAI N.Y
JUNE 19, 1937

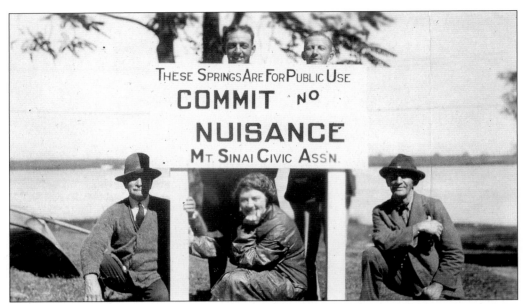

Members of the Mount Sinai Civic Association, which incorporated in 1916, surround a sign erected by the group c. 1940 to protect natural springs located in the harbor area. A pipe was installed to lead the water from the natural spring, or seep, out of the hillside. The presence of cattails above the ground indicated the existence of fresh water underneath. Residents would come to fill containers with the natural 57-degree spring water. Public use of the spring ended sometime before 1978.

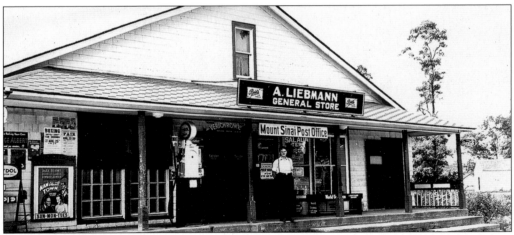

The Mount Sinai post office and general store are depicted here in 1938. In 1934, postmaster Mark H. Davis died, and Charles T. Davis, pictured here in front of the A. Liebmann General Store, took over the position. The store section of the building, located on the northeast corner of North Country Road at the intersection of Mount Sinai-Coram Road, was taken over by Augustus "Gus" Liebmann. A succession of businesses have occupied the building since the post office was moved from this location to a new building on Route 25A in 1975.

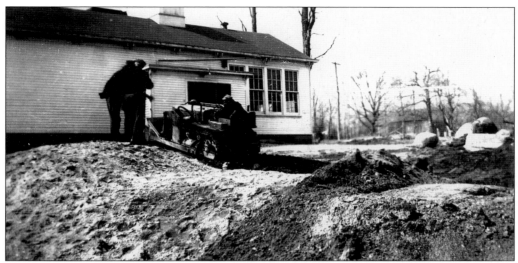

The devastating "Great Hurricane of 1938" felled trees and power lines in Mount Sinai, as well as all over Long Island. Winds exceeding 120 miles per hour battered eastern Long Island, and waves as high as 50 feet hit the shoreline in some places. The Category Three hurricane struck on September 21, 1938, and about 70 people died as a result of the storm. Newspapers reported the "miraculous escape" Frank Leedham made from his houseboat on Mount Sinai harbor during the hurricane. The photograph of the school building was taken as residents cleaned up after the storm. Below, the property around Anneta Davis's cottage, located on Mount Sinai-Coram Road just north of the power lines that now run along Route 25A, sustained significant damage from this terrible storm.

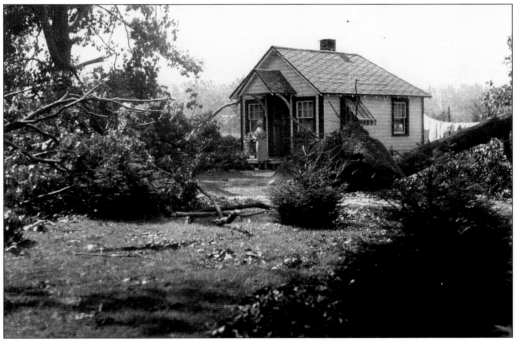

This view of Platford's dock was taken in the 1920s, before dredging changed the look of the harbor. Notice the vegetation evident during low tide. The sand bar at the mouth of the harbor prevented all of the water from draining out at low tide at this time. Dredging activity soon changed the harbor forever. Allegedly, the town of Brookhaven secretly granted a dredging permit to the Seaboard Sand and Gravel Company on May 7, 1927, against residents' vehement opposition to the removal of sand and gravel from the harbor. The protective sand bar was removed by the extensive dredging, and all the water drained from the harbor during low tide. High tides were higher and low tides lower, leaving the harbor a vast mud flat during low tide. The postcard below depicts a beach scene at the pavilion on Cedar Beach.

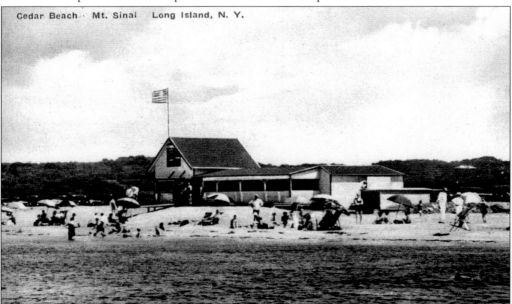

Cedar Beach · Mt. Sinai Long Island, N. Y.

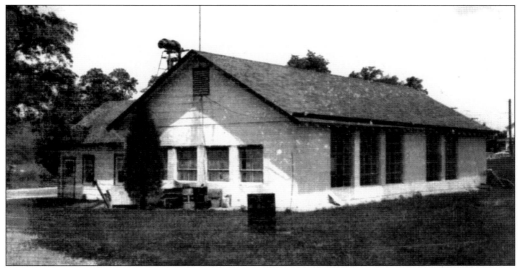

This photograph depicts the meeting room constructed as an annex to the firehouse. Singer Stuart Gracey gave a successful concert to raise money for the annex, and the cornerstone was laid on August 7, 1948. Residents enjoyed square dances, parties, bingo, and card games here. The building is currently known as the North Country Road Community House. The original firehouse was taken down in 1963, when the fire district erected a new facility at the intersection of North Country and Mount Sinai-Coram Roads.

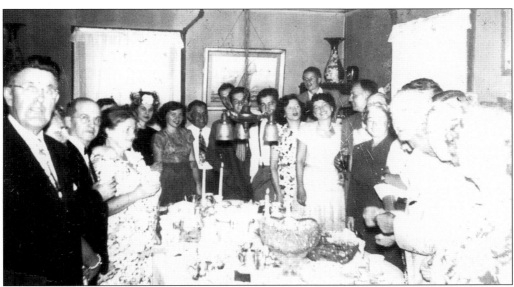

Robert C. Griffiths's nephew George Edsall married Frances Orehek at the Mount Sinai Congregational Church on August 11, 1948. Rev. Frank Voorhees, minister of the church from 1916 to 1948, performed the ceremony. The groom's aunt, Eliza Jane Griffiths, hosted a reception at her home on North Country Road. Guests seen here are, from left to right, Robert C. Griffiths, John Hoffman, Mrs. Orehek, June Allen, Martha Jane Baldini, two unidentified guests, Tom Orehek, Gene Orehek, Muriel Orehek, the bride and groom, unidentified, Val Orehek, Mrs. Cornell, Murray Christie, Kay Orehek, and Eliza Jane Griffiths.

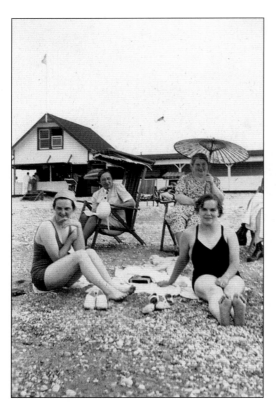

Pictured at Cedar Beach in 1939 are Mount Sinai residents Mrs. Partridge, Dorothy Truesdale, Grace Hunter, Bettina Hunter (Grace's daughter), and Reverend Hunter (Grace's husband). The Hunters lived on North Country Road.

Frances and George Edsall spent the day at Cedar Beach sometime during the late 1940s or early 1950s. The couple met in Mount Sinai and married at the Congregational church in 1948. George was the grandson of Robert Griffiths, and he spent vacations visiting family there.

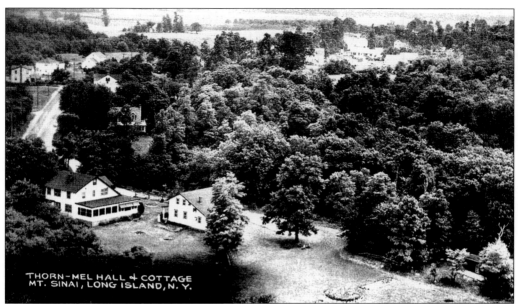

THORN-MEL HALL & COTTAGE
MT. SINAI, LONG ISLAND, N.Y.

These postcard views of Thorn Mel Hall and cottage were taken *c.* 1940. The beautiful aerial view offers a glimpse of the natural beauty of the harbor and surrounding community. Dr. W.L. Davidson, a minister from Baltimore, built Thorn Mel Hall as a summer residence. The buildings are on the north side of North Country Road, at Rocky Hill Road, at the top of what is locally known as Captain Dick's Hill. After World War II, Thorn Mel Hall became a restaurant and catering facility, but went out of business and became a rest home for military veterans during the 1950s and 1960s. In the 1980s, the veterans home was renamed Forest Mist Manor. Community problems and protests ensued, and in the 1990s, the complex was converted back for use as private residences.

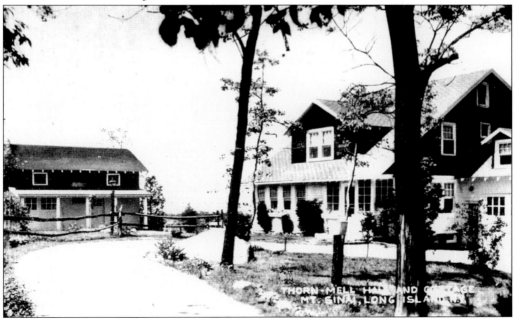

THORN-MELL HALL AND COTTAGE
MT. SINAI, LONG ISLAND, N.Y.

A horse riding academy operated from the Samuel Davis homestead during the 1940s, when the Downs family owned the property. Members of the Gracey, Were, Winbeck, and Downs families are shown in front of the barn on the property. Alfred "Johnny" and Honor Kopcienski purchased the 15-acre property in 1959 and have restored the buildings with careful attention to historical accuracy. Additional buildings have been moved to the homestead and restored. One such building is the William "Painter" Davis studio, originally used by Davis, a popular Long Island genre painter, as his summer studio at another Mount Sinai location.

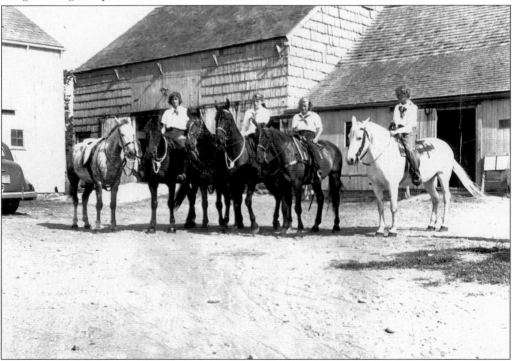

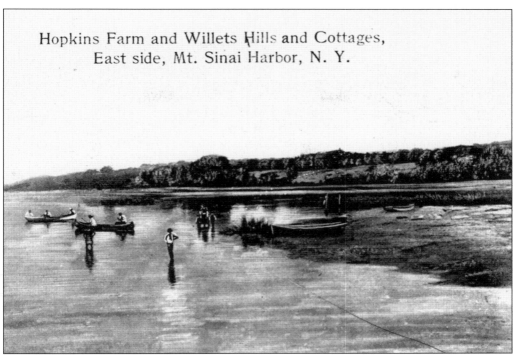

Hopkins Farm and Willets Hills and Cottages,
East side, Mt. Sinai Harbor, N. Y.

This postcard offers a view of what is now known as the Chandler Estate from the harbor. The aerial view of the 42-acre property showing the beach and waterfront area seen below was taken during the 1940s, when the North Shore Camp for Children was run there. Activities at the camp included baseball, tennis, volleyball, basketball, and handball. Sailing, rowing, and motoring were offered, as well as crafts. A theater and indoor recreational facilities were constructed sometime after 1941.

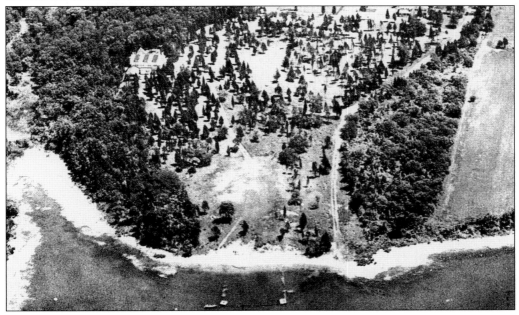

Arthur Miller
102 Pierrepont Street
Brooklyn, 2, New York
Main-5-2928

February 8, 1946

Dear Mr. Hopkins;

After returning from Port Jefferson this evening,
I called Mr. John Meehan about renting his house. He has decided
not to rent this summer.

I hesitate to send you a deposit on the Pringle
house, across the road from the Lind house, because I was not able
to see the inside. I am very anxious to get something at Mt. Sinai,
however, because of our friends the Bells being there, and also Mr.
M and Mrs. Rosten, who will be taking the Murdoch house again. So
I wish you would write me and let me know what day I can see the
Pringle house.

Meanwhile, I would greatly appreciate it if you would
let us know about anything really suitable that comes to your at-
tention. We would prefer something more like the Meehan house than
the bungalow-type Pringle place. And as I told you, my being a
writer makes it best if the place is a little secluded and quiet.

As a final suggestion, do you have anything like the
Murdoch house which Mr. and Mrs. Rosten had the past two summers?

Hoping rather fervently that you will find something
for us,
 I remain,

 Sincerely yours,
 Arthur Miller
 Arthur Miller

This letter, signed by author and playwright Arthur Miller in 1946, indicated how popular
Mount Sinai was as a summer retreat for the New York City theater crowd during the post
World War II years. Miller's friend, playwright Norman Rosten, rented several properties in
Mount Sinai, including a home located on the Chandler Estate.

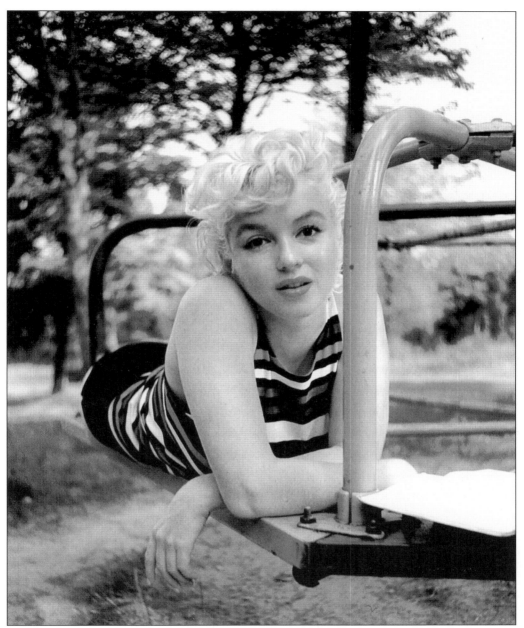

Marilyn Monroe spent time in Mount Sinai visiting playwright Norman Rosten and his wife Hedda. The Rostens were renting a house at the Chandler property. Photographer Eve Arnold posed Monroe for several pictures on the children's carousel and among the rushes along the shore of the Chandler property in 1955. Her biographers have indicated that Monroe cultivated her friendship with Rosten to become closer to his good friend, Arthur Miller, whom she later married. Monroe created a sensation by visiting the public beach in Mount Sinai, where fans surrounded her in the water. Photographer Eve Arnold recalled that a Good Samaritan (local resident Fred Lorch) in a passing boat rescued Marilyn. (Photograph by Eve Arnold, courtesy Magnum Photos.)

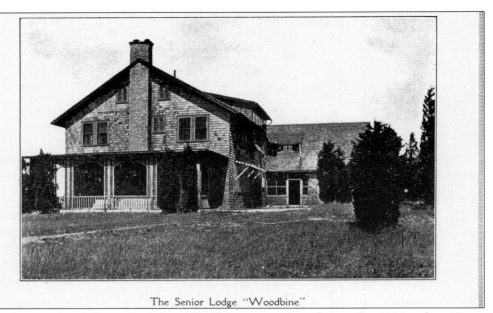

The Senior Lodge "Woodbine"

This photograph of the main lodge, Woodbine, was taken during the 1920s when Camp Sewanhaka operated at what was later the Chandler Estate. *Seawanhaka* is a Native American term for "Isles of Shells." This building was located on a knoll set among tall red cedar trees, about 200 yards from the beach. Sewanhaka was a summer camp for girls offering folk and social dancing, arts and crafts, and tutoring in all subjects. This upscale camp offered electricity and running water, as well as a full dining hall.

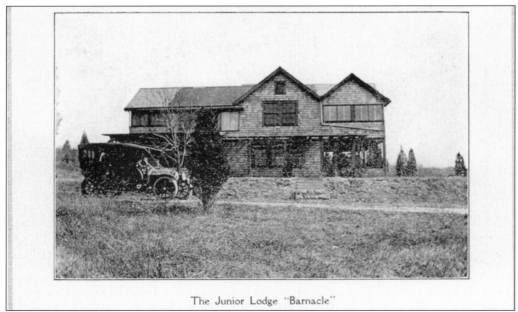

The Junior Lodge "Barnacle"

Barnacle Cottage at Camp Sewanhaka offered more rustic accommodations for campers, where girls who preferred to rough it could sleep in the open air, on sleeping porches, or in tents on the grounds.

Five

A Farming Community Transformed

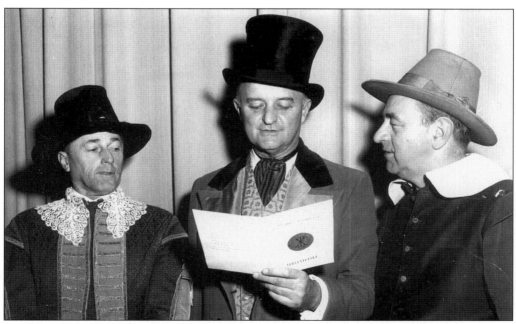

Brookhaven town trustees Andrew Huskisson, Judge Kenson D. Merrill, and Stuart Gracey of Mount Sinai are pictured in period costume during the town of Brookhaven's tricentennial celebrations in 1955. Stuart Gracey, who moved to Mount Sinai from upstate New York in the 1940s, purchased the Tillotson house. He served as town trustee from 1950 to 1959. Henry D. Silverman, another Mount Sinai resident, served as a Brookhaven town trustee from 1927 until 1937.

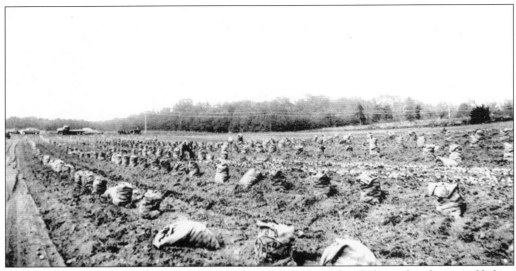

Mount Sinai resident William Van Pelt Davis ran the farm that belonged to his grandfather, Lorenzo G. Davis, from 1915 until the 1970s. This photograph shows a potato field at harvest time, with bagged produce ready to be marketed. The farm was south of North Country Road and west of Mount Sinai-Coram Road. In the 1970s, Davis sold the property to the Mount Sinai school district, and the school complex now stands on this site. Below is a view of workers in the field at harvest time. Agway, a long time Mount Sinai business located on Route 25A, originally started out as a potato storage barn and sorting facility.

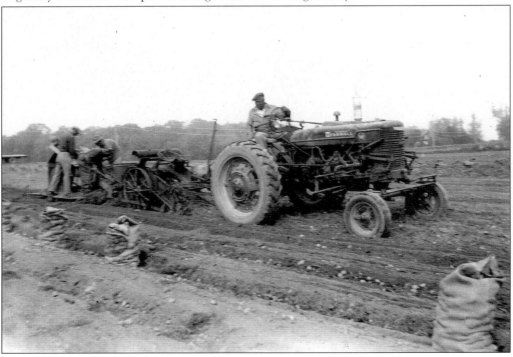

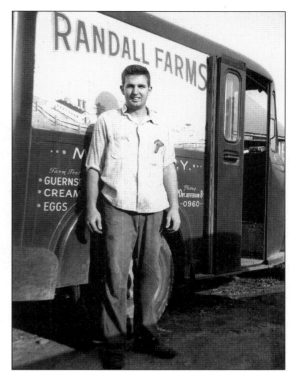

Harry Randall posed in 1953 in front of a dairy delivery truck. Beginning in 1942, John Randall purchased a local milk route. Randall Farms pasteurized milk in a cinderblock milk plant. By 1945, the dairy plant was processing milk from nine other dairy farms in Suffolk County. Randall Farms grew to include six home delivery milk trucks that peddled milk, eggs, cream, and other dairy products in northern Brookhaven, from Saint James to Rocky Point. From 1950 to 1965, the farm and dairy operation employed 25 people. The Randalls stopped their milking operation in 1968 and purchased milk from surrounding dairies for processing. Below is a view of the milk plant c. 1940.

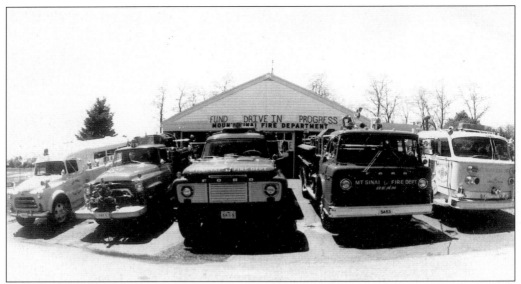

In 1963, a new firehouse was constructed on the west side of Mount Sinai-Coram Road at the intersection of North Country Road on the site of the original one-room schoolhouse, which was no longer used by the district after 1958. As population and development in Mount Sinai increased, the Mount Sinai Fire Department constructed a two-bay substation on Wheat Path and Mount Sinai Avenue in 1973. Dedication ceremonies were held on August 4, 1974. The substation was extended in 2001 to accommodate the increased demand for services.

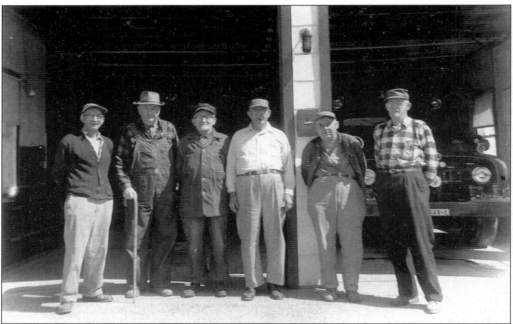

Mount Sinai Fire Department fire police Oswald F. Coote, Amherst Davis, Fred Scheurenbrand, Charles Dawson, William Van Pelt Davis, and Fred Lee posed in front of the firehouse c. 1959. These men were former chiefs and retired firefighters now relegated to light duty, such as directing traffic at fire sites.

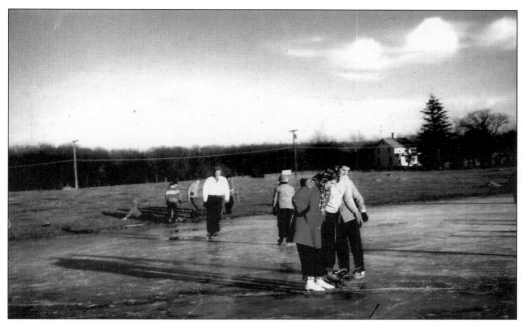

Many local residents and neighbors of the Randall family enjoyed winter ice-skating on Randall's pond. Harry Randall is pictured with his wife, Florence, in front of the pond in this 1957 photograph. Beginning in the early 1900s, ice was cut from the pond throughout the winter and stored in an icehouse for use in the dairy operation during the warmer weather. The icehouse had eight-inch-thick walls filled with sawdust and shavings to insulate against melting. Floating the cans in a cement pit filled with water and ice cooled the milk. Below, Warne Randall paddled a homemade raft across the pond at Randall Farms *c.* 1954. The barn and silo can be seen in the background.

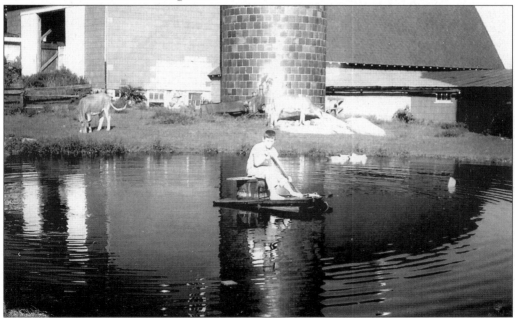

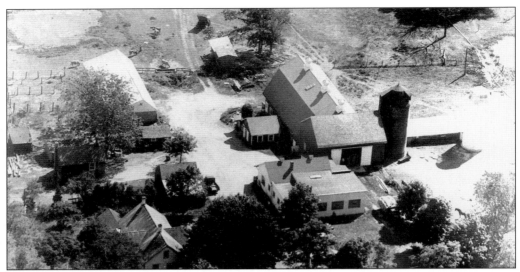

This aerial view of Randall Farms was taken during the 1960s, when John Randall owned and operated the 75-acre farm and dairy. The main house is located on the north side of North Country Road, west of Mount Sinai-Coram Road. Randall ran the farm and dairy, located between North Country Road and Route 25A, east of Mount Sinai-Coram Road up to School Road. In 1970, 60 acres were sold and developed as single-family homes. The farm's remaining 15 acres were sold and developed in 1982.

During the 1960s, John and Mary Elizabeth "Betty" Randall ran a dairy farm on North Country Road in Mount Sinai. They hosted classes of local schoolchildren for tours of the farm for many years until the class sizes became too large to be accommodated. The Randalls gave each child a free half pint of fresh milk and a Randall Farms pencil at the end of their tour. John graduated from Cornell University's agricultural program in 1927, and he returned to work on the family farm. A large addition was put onto the barn as the dairy operation expanded to 45 cows. John and Betty had three sons: Harry, Forrest, and Martin.

John S. Randall is pictured milking one of his Guernsey cows on his dairy farm in the 1960s. Guernseys produce high-fat milk, and the cream could be separated and sold. Fifty-five head of cattle were milked at this time. Randall was active at the Mount Sinai Congregational Church, and was a past president, life member, and past chief of the Mount Sinai Fire Department. He died of a heart attack in 1976 at the age of 66.

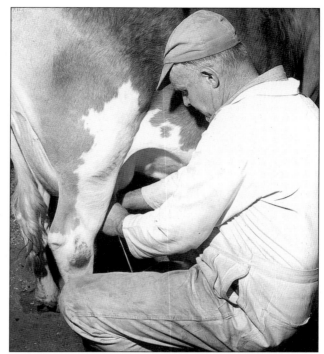

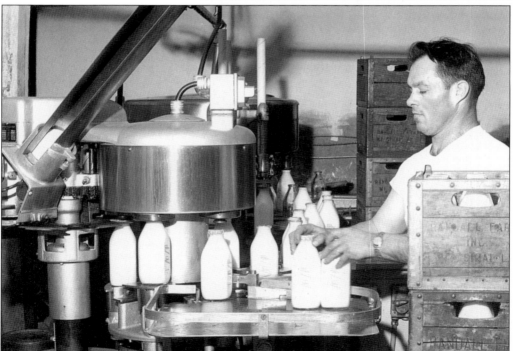

Klem, who worked at Randall Farms, is shown packing milk bottles into cases ready for market. The dairy operation at Randall Farms began in 1889 with the construction of a dairy barn by Forrest B. Randall.

This 1956 photograph depicts Mount Sinai residents Harry Randall, William Edward Davis, Warne Randall, and Amherst Davis storing bales of hay in the barn at Randall Farms. Bill Davis is on the hay wagon. Hay was grown and gathered as winterfeed for the farm animals. Below, Forrest B. Randall II is pictured raking alfalfa hay using an F-14 tractor c. 1955 at Randall Farms.

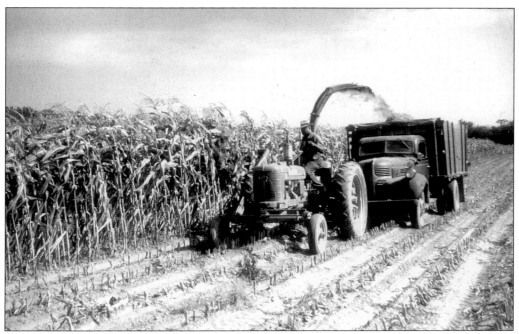

Mount Sinai resident George Harris is shown chopping corn silage using an H tractor at Randall Farms c. 1956. Below is a view of a cabbage field in fall, just before harvest time. Local residents have long recognized the pungent odor of cabbage in the field around harvest time.

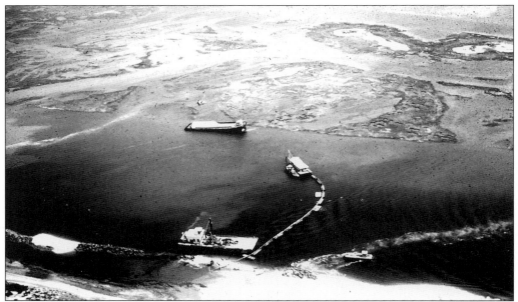

Large-scale dredging began in Mount Sinai harbor again in the mid-1950s. After receiving a permit from the U.S. Army Corps of Engineers, the town of Brookhaven gave permission to dredge the wetlands. By 1969, over 60 percent of the wetlands in the harbor were destroyed. Profits were made on the material removed from the harbor, and a 40-foot deep channel was dug into the salt marshes south of Cedar Beach and in the western part of the harbor. Unsalable material was dumped onto the northern end of the barrier beach, resulting in the destruction of ancient groves of red cedar. This aerial view offers a clear representation of the extensive work being done on the harbor. Below is a close up image of the dredge itself.

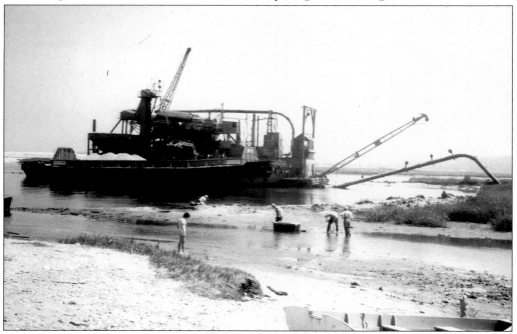

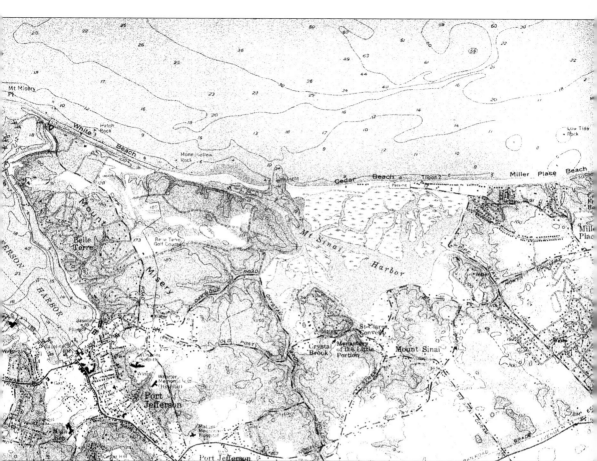

This 1955 Geological Survey map offers a view of the Mount Sinai area. Local landmarks such as Cedar Beach, the Little Portion Monastery, Poor Clare Convent, and Crystal Brook development are marked on the map. Note the extensive marshland areas in the harbor. Dredging of Mount Sinai Harbor in the 1950s and 1960s led to an increased awareness of the significant damage these cavities could create for the natural environment. Legislation was eventually passed with the help of Robert Cushman Murphy to prevent similar damage to other New York State wetland areas. (Courtesy State University of New York, Stony Brook.)

HOME COOKING

"A GOOD PLACE
TO EAT."

H. R. 3-9880

J & R
Paddock

ROUTE 25A
MT. SINAI, N. Y.

The J&R Paddock restaurant was located at the southeast corner of Chestnut Street and Route 25A. This matchbook cover dates from sometime during the 1960s and offered Mount Sinai residents and guests "a good place to eat."

Above is a postcard depicting Rulau Lumber as it looked *c.* 1960. The building was located on the north side of Route 25A, where WTC Tire is today. The Mount Sinai business district was concentrated along this roadway and consisted of businesses such as the Sieger Agency, a print shop, and Agway, which started out as a potato storage barn and sorting facility. (Courtesy Bill Wolf.)

Members of the Mount Sinai Fire Department were invited to drill at Grumman Aerospace company in 1965. Grumman held training sessions detailing techniques for handling possible airplane crashes for local fire departments. Pictured are, from left to right, Dave Hulsberg, Frank Gallagher, Martin Randall, Paul McCusker, Chet Makowki, Bruce Loucka, Joe Niegocki, John Lechtaler, Harry Randall, Bill Bornstein, Vinny Lee, Charlie Elsebough, Gene Gerrard, John Lukasz, and Bill Ging Jr.

Ralph and Barbara Davenport purchased what had originally been Satterly's Landing from George Platford Jr. for $16,000 in 1961. The home is pictured here as it looked just before they moved in with their children, Susan, Ralph, and Dori. The family pet, Arnie, a 300-pound pig, spent his days at the boatyard.

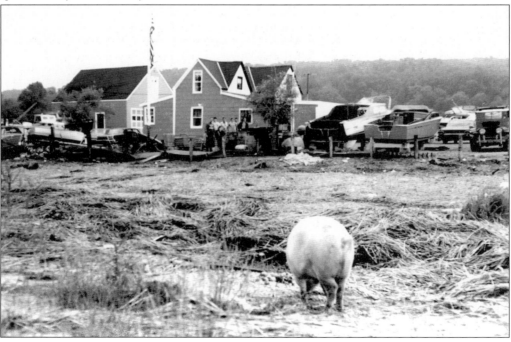

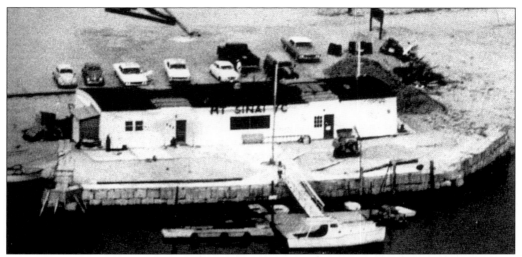

The Mount Sinai Yacht Club was incorporated on May 18, 1964, as a place for enthusiasts to share their pleasure in water recreation and to offer a safe haven and hospitality to other boaters on Long Island Sound. In 1966, a retired barge was purchased for $800 and moved to a 150-foot strip of land leased from the Tuthill family. The clubhouse, dock, and grounds are pictured as they appeared in 1964. The yacht club had a membership of 200 in its first year of operation, and membership has grown to over 250. The club runs programs like a junior sailing program, an annual club cruise, the Commodore's Breakfast, Christmas and Easter parties, and an annual clambake. Construction on a new $1 million clubhouse began in 2003.

In this July 1969 photograph, Barbara Davenport is pictured with Mount Sinai resident Ed Hessler at an outing arranged for the students at Maryhaven. As many as 35 local boaters volunteered to take the students on a day trip, organized by Ralph's Fishing Station each year to give the children an opportunity for a day in the sun and on the water. Three or four students were assigned to each private boat, providing a family atmosphere.

DEDICATION

MT. SINAI ELEMENTARY SCHOOL

JULY 24, 1966

Mount Sinai's two-room schoolhouse, constructed in 1870, was no longer used after 1958, and residents were schooled in Port Jefferson for a time. The new Mount Sinai Elementary School was officially dedicated on July 24, 1966, and educated grades kindergarten through eight. A rendering of the proposed school building accompanied a flyer sent to residents in July 1964. The projected cost of the building was $596,340. An extension on the elementary school was added in 1973 to accommodate increasing enrollment.

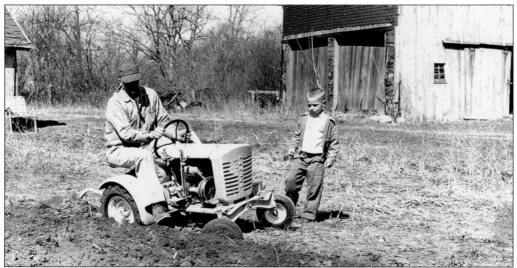

Alfred "Johnny" Kopcienski is shown operating a tractor at the Samuel Davis homestead in May 1963. His son Mark watches, with the old barn (before structural changes were made) in the background. An addition was later removed due to extensive damage, and the main barn was restored. Farming was a big part of Mount Sinai's heritage and continued to be an important commercial activity within the hamlet until the last large tracts of farmland were sold to developers during the 1990s.

Six

DEVELOPMENT AND
PRESERVATION

The religious community of the Poor Clares of Reparation was originally established in a carriage house at the Little Portion Monastery in 1928. Funds for a new building were raised by conducting a dime appeal in 1931 with a goal of raising $10,000. In 1939, the nuns acquired property on Old Post Road, a quarter of a mile away from Little Portion. A brick house was on the site, and the "house that dimes built" was moved down the hill in July 1940 to the Poor Clares' new home, Maryhill. Pictured here is the home of the community as it looked during the 1990s. The last two remaining sisters sold the property in the 1990s, and moved back to a building on Little Portion.

Young Anne and Karen Randall are pictured enjoying the harvest at apple-picking time at Randall Farms in 1971. The apple orchard was established by Forrest Randall and continued in operation until the farm was sold. Randall's apple stand at the farm is pictured here *c.* 1970. As part of the farm operation, fresh produce was sold to local residents from this seasonal stand on Randall Farms.

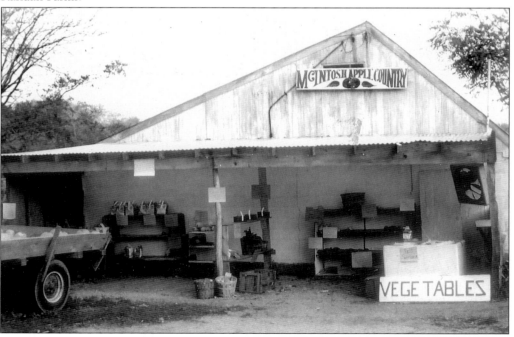

The 1960s saw an explosion of residential development in Mount Sinai, as farm families found maintaining their land increasingly expensive, and suburban sprawl moved east to Suffolk County. This photograph shows the development on Vidoni Drive, off Route 25A, behind the school complex. This acreage was originally owned by John Babski, a Mount Sinai potato farmer. Below is a photograph of the Mount Sinai post office in its location on Route 25A. The post office was opened here in 1975, when Benjamin Bailer was postmaster.

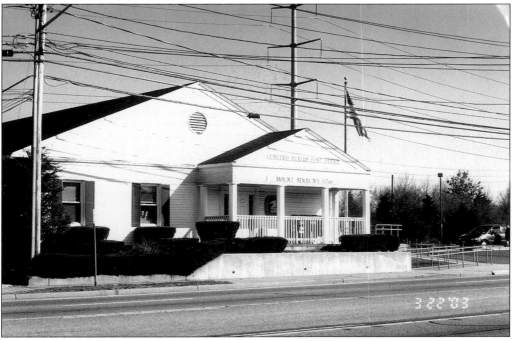

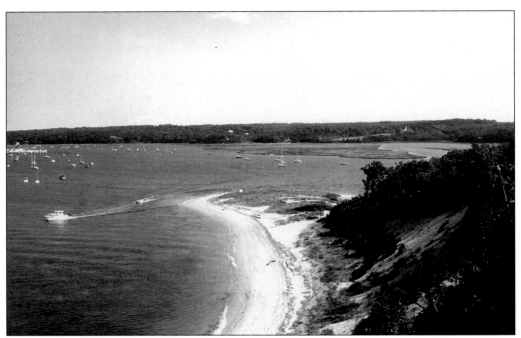

Mount Sinai Harbor was and continues to be a very busy place. This view of the harbor was taken in October 1971. Below is a photograph of a mud baseball game, played in front of Ralph's Fishing Station, where the water was transformed into a meadow of mud for two to three hours a day. Players had a game in the mud while onlookers cheered from nearby boats. Ralph Davenport began this tradition in 1968 and dubbed the game "mudball."

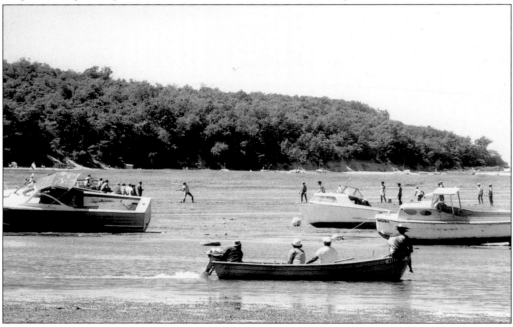

Clammers have traditionally taken advantage of the abundance of clams available in Mount Sinai Harbor. Local residents recall how busy Shore Road was in the summer, with dozens of cars parked along the roadway and clambers in the harbor. Commercial fishing has long been part of the economy of the harbor and includes clamming, fishing, and lobstering.

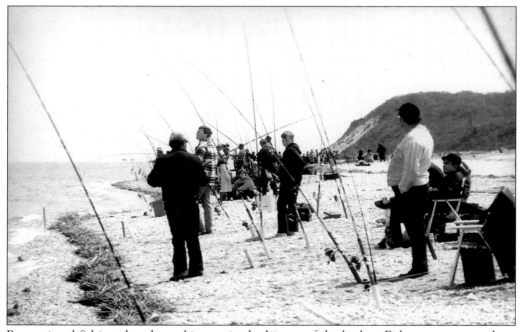

Recreational fishing also plays a big part in the history of the harbor. Fishermen are seen here at a May 1974 fishing contest on Cedar Beach. Mount Sinai Harbor is home to hard clams, American oysters, ribbed mussels, flounder, bluefish, snapper, and blackfish, as well as a wide variety of waterfowl.

This is an aerial view of Ralph's Fishing Station when it was located on Shore Road during the early 1970s. Ralph Davenport and his wife Barbara bought the property, originally owned by L. Minor Satterly, from George Platford in 1961. In 1975, the town of Brookhaven condemned the property as it began developing recreational facilities at Cedar Beach. Ralph's Fishing Station was moved to the north side of the harbor, and the Davenports opened a new fishing station in 1977. Below is the last photograph taken of Ralph's at its original location on Shore Road.

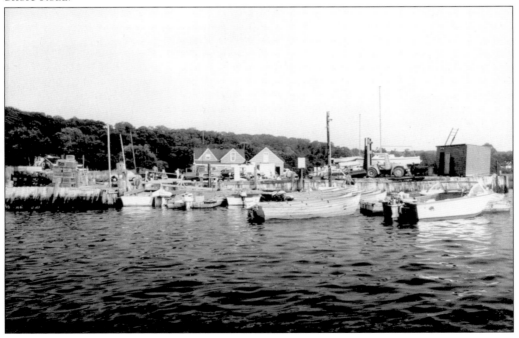

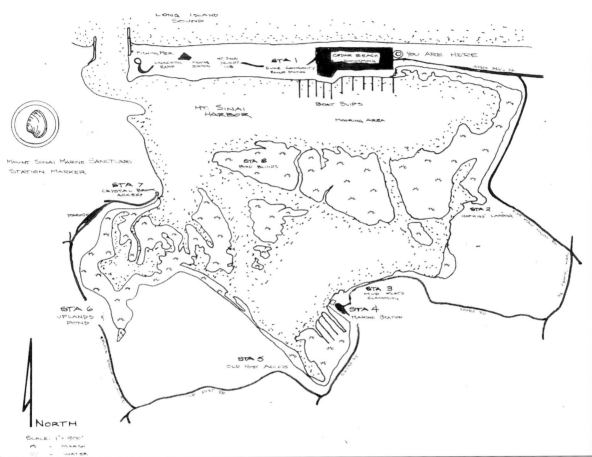

Thomas Cramer drew this 1975 diagram of the Mount Sinai Harbor area in cooperation with town environmental protection director George Proios, the Mount Sinai Advisory Committee, and the state's department of environmental protection as part of a plan for Brookhaven to develop the harbor into an active recreational area. The plan included a protected area for swimming at Cedar Beach, boat slips and a mooring area, a marine sanctuary, fishing station, launching ramp, and fishing pier. (Courtesy the Special Collections Department, Stony Brook University.)

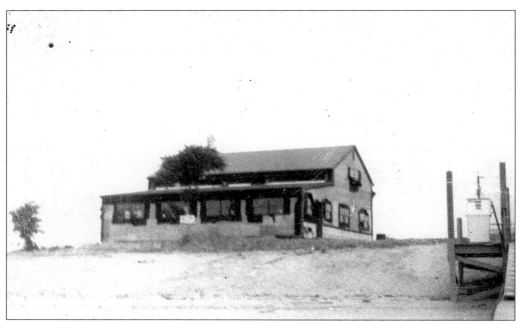

This is the first photograph taken of Ralph's Fishing Station at its new location on Mount Sinai Harbor. The Davenports slowly rebuilt their business after being forced to move by the town of Brookhaven. Joel Bender, a local lobsterman, is pictured below with his daughter Kristen in 1980. Note the lobster pots piled high on the *Kristen Victoria*. Lobstering saw a huge increase in productivity and participation during the late 1980s and early 1990s. A severe die-off occurred in 1999, possibly caused by insecticide use, and wreaked havoc with the local industry.

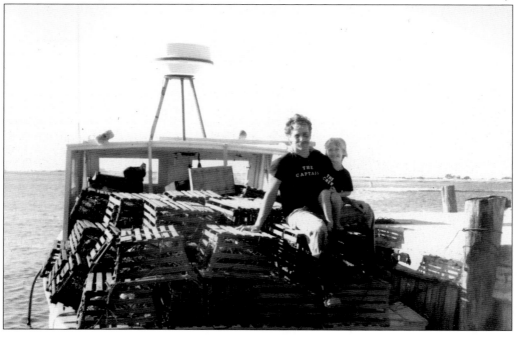

This 1976 view of the state's Route 25A was taken at the intersection of Mount Sinai-Coram Road. The McGovern Sod Farm is on the left, with the local printing shop at the edge of the grassy area. An office building can be seen on the right side of the photograph. This photograph was taken before the expansion of Route 25A to a four-lane highway in the 1990s.

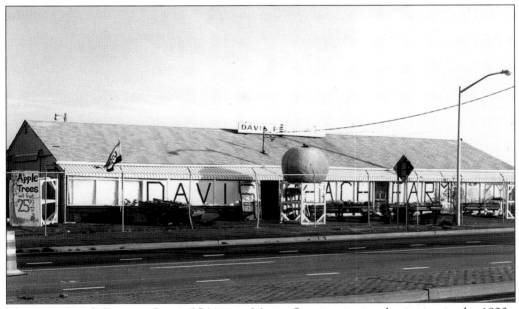

The Davis Peach Farm on Route 25A was a Mount Sinai institution beginning in the 1920s, when Archer Davis planted his first trees. At its peak operation, more than one million peaches in hundreds of different varieties, passed through the Davis peach stand each year. The Davis family owned a considerable amount of property in Mount Sinai, including the land where housing developments on Peach Tree, Apple, and Cherry Lanes were built. The roadside stand, located where the Ranches development is now, closed in 2000.

Charles W. Barraud, a lifelong Mount Sinai resident, served as the supervisor for the town of Brookhaven from 1966 to 1975. Barraud was appointed to fill the term of Charles Dominy, who resigned in November 1966. Previously, he had served as town assessor and superintendent of highways for 13 years. Barraud was a Mount Sinai fire chief from 1943 to 1945 and fire commissioner from 1953 to 1962. County Road 83 was renamed in his honor in the 1990s.

The Barraud family home was built along Route 25A, then known as Hallock Avenue, in the early 1900s. This view, looking east just north of Route 25A, shows the house in 1976, before the widening of the road and the construction of the real-estate office on the opposite corner.

Mount Sinai resident Eugene Gerrard served as a trustee on the Brookhaven town board beginning in 1981. Gerrard also served as chief of the Mount Sinai Fire Department from 1970 to 1971.

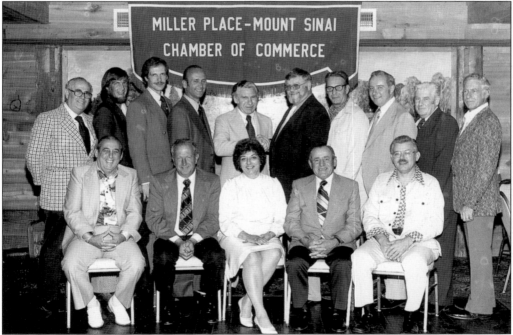

This photograph of the Miller Place-Mount Sinai chamber of commerce was taken during the 1980s. Pictured here are, from left to right, (front row) Bud Maggio, Ralph Davenport, Dottie Ackerman, Peter "Robbie" Abramowski, and unidentified; (back row) Henry Berne, unidentified, Arthur Von Achen, Joe Manning, Harold Malkmes, Fred Lorch, Bob Marsh, Frank Favor, Jim Blyth, and Jack Eckhardt.

This photograph of the student body and faculty was taken during celebrations held at the school in 1976 for the nation's bicentennial. In the 10 years the school had been educating Mount Sinai students, the enrollment went from 144 to 994. The total population of the hamlet in 1970 was 5,998, and the population in April 2000 was 8,734.

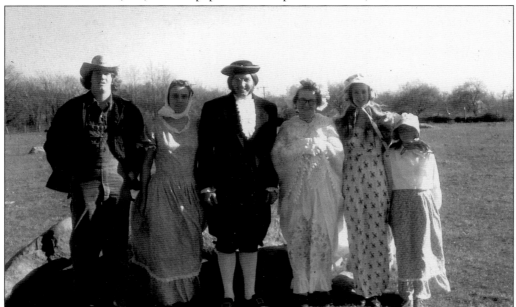

Festivities at the Mount Sinai Congregational Church in celebration of the nation's bicentennial included dressing up in period costumes and traveling to church in a horse and wagon. John, Florence, Harry, Betty, Karen, and Anne Randall posed in the farm pasture before the drive to Sunday services. The church saw many changes in its long history In 1926, a parish house was built onto the church at a cost of $3,000 and was enlarged in 1954 to accommodate an active and growing parish family. Classrooms were constructed under the meetinghouse with a bequest given by the Wicks family in 1976.

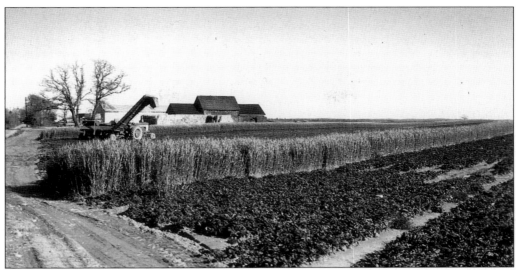

The Abramowski family has farmed in Mount Sinai since the 1940s, when brothers George and Peter "Robbie" Abramowski moved east from Hicksville and bought 50 acres of property from William Wicks. Harrison Roe owned the property before Wicks. Another 100 acres was purchased soon after. The Abramowskis grew vegetables for the wholesale market. This view of the farm was taken in 1974 before a large housing development was built to the south, which includes Plymouth Avenue, between Canal Road and Mount Sinai-Coram Road. The Abramowski farm was the last family owned and operated farm in Mount Sinai.

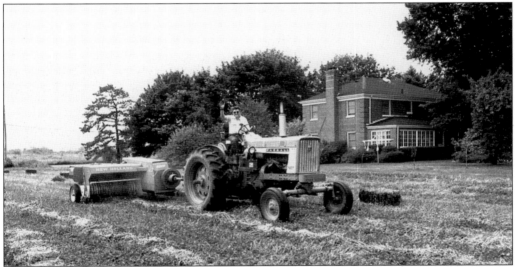

Harry Randall is pictured baling hay at his father-in-law Charles Bergold's farm on the east side of Mount Sinai-Coram Road, south of County Road 83, during the 1970s. Bergold's brick home was built in 1948, when he moved with his family to Mount Sinai from Hicksville. Bergold farmed his land until it was sold for development in the 1980s. This farm was part of the Villages at Mount Sinai development that includes the Ranches at Mount Sinai, Timber Ridge at Mount Sinai, and the Hamlet at Willow Creek golf course and residential homes. The Tallmadge Historical Trail crossed Bergold's farm and will be preserved from development as part of the settlement of the Villages at Mount Sinai lawsuit.

Margaret Alfano, longtime resident and activist, is pictured here c. 1981. Margaret and her sister, Nora Seif, moved with their families to Mount Sinai in 1968. In 1970, they started a Scholarship Garden to raise funds for annual scholarships given to outstanding Mount Sinai high-school students. Margaret was very active in the Mount Sinai Civic Association and served as its president for many years until her retirement in 1996. In 1981, plants donated by the Nora Seif Scholarship Fund and the Port Jefferson Moose Lodge were used to establish the garden seen in front of the Mount Sinai Middle School, built in 1980, in the photograph below.

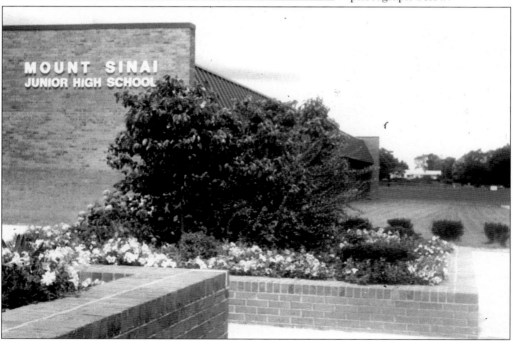

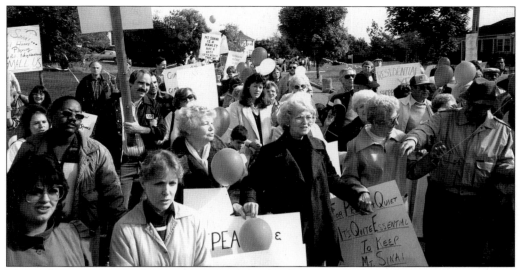

Mount Sinai residents vehemently opposed the development of a large shopping center on the corner of Plymouth Avenue and Canal Road in 1986. The site of the proposed mall was adjacent to a quiet residential neighborhood. The Mount Sinai Civic Association garnered massive support for its opposition to this proposal, and, with the help of town supervisor Henrietta Acampora, was able to have the zoning on the property changed to residential use only. Plymouth Estates, a planned retirement community, will begin construction on the site in 2003.

The Mount Sinai Civic Association, established in 1916, celebrated its 75th anniversary in 1991 with a community celebration. Festivities included a historical display of old community photographs at a special meeting, which was well attended by local residents. Pictured here are, from left to right, executive board members Ann Becker, Eileen Trombino, Margaret Alfano, and Phyllis Buschmann.

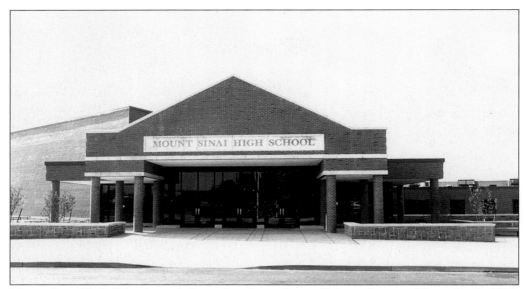

Mount Sinai High School was dedicated to the students of Mount Sinai on November 3, 1991. Prior to the opening of the high-school building, Mount Sinai students attended Port Jefferson High School, which had served as a regional high school for area students. The high school, featured in *American School and University* magazine's 1991 architectural portfolio issue, was constructed at a cost of $24.4 million. The building encompasses 155,000 square feet, and it has the capacity to serve over 1,100 students.

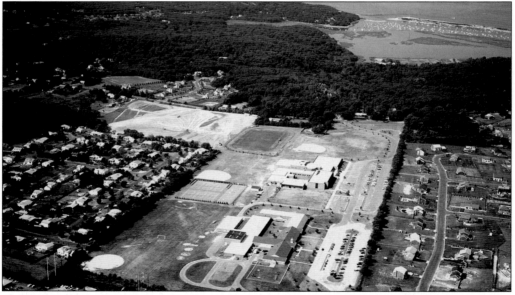

This 1989 aerial view of the school complex surrounded by residential developments offers a panoramic view of the harbor in the background. Taken before the construction of the high school in 1991, this photograph clearly shows the elementary school building, built in 1973, and junior high school, built in 1980. After students completed the eighth grade in Mount Sinai schools, they attended high school in Port Jefferson at this time. (Courtesy Ozone Aerial Photo.)

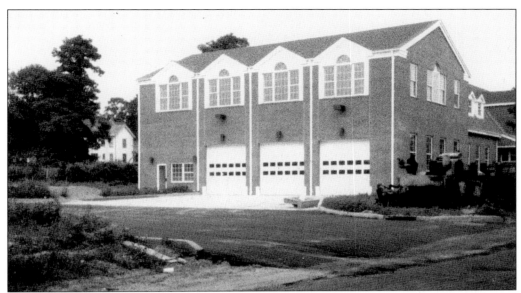

The Mount Sinai Fire Department began construction in 1989 on a spacious addition to its firehouse on Mount Sinai-Coram Road. The new firehouse was needed in order to accommodate the additional equipment needed to ensure the safety of the local community. It was dedicated in 1991. In 2003, the Mount Sinai Fire Department recognized Harry Randall and Bob Davis for their many years of service. Davis, a charter member of the department, was given the rank of honorary chief. Randall was honored for his 50 years of service, which began when he was 18 years old, and March 1, 2003, was proclaimed Harry Randall Day in the town of Brookhaven.

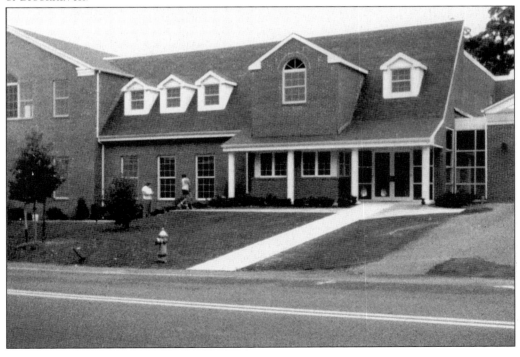

Over 5,500 years ago, a large Native American village was located on the south shore of Mount Sinai Harbor. Dr. David Bernstein, anthropology professor at Stony Brook and the director of the Institute for Long Island Archeology, is shown here on the site of a dig at Eagle's Nest in the early 1990s. According to archeologists and marine science researchers, this was one of the most densely populated areas in the Long Island Sound region for thousands of years before the arrival of Europeans. Native American activities on this site likely included shellfish processing, butchering, stone tool manufacturing, and cooking. The diet of the Native Americans living at this site likely consisted of deer, seal, small mammals, clams, fish, birds, and reptiles. Thousands of artifacts dating from approximately 3,500 B.C. were removed from Eagle's Nest. Below, students are shown working on the site, with a clear view of the harbor visible in the background.

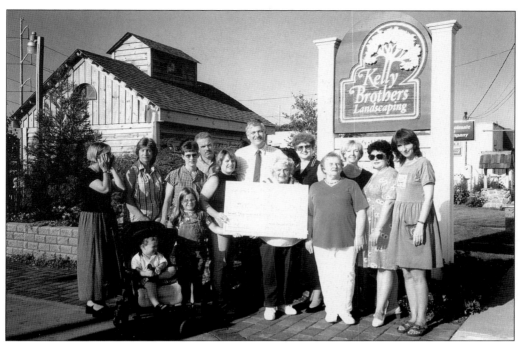

This photograph was taken to commemorate a state grant in the amount of $7,000 procured for the Mount Sinai Civic Association by state assemblyman Steven Englebright in 1998. The money, along with an additional grant of $250,000, was used to plant over 350 trees along Route 25A in Mount Sinai as part civic beautification efforts. Pictured from left to right are Lynne Edsall, Ann Becker, Mary Fratianni, Bill Kelly, Lori Baldassare, Steven Englebright, Margaret Alfano, Deirdre DuBato, Maureen Winters, unidentified, Liz Desimine, and Jane Edsall. In front is a toddler of the Fratianni family and Katie Sperin. Board member Ernie Bastiaans, who designed the "Welcome to Mount Sinai" signs on Route 25A, is not pictured. Below is a view of Route 25A after the state widened the road to four lanes in the early 1990s.

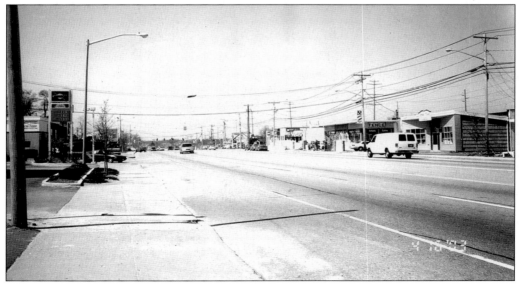

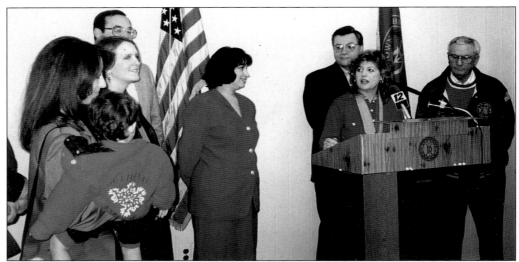

A press conference was held in the Suffolk County government complex in Hauppauge in February 1997 to announce the settlement of a lawsuit brought by the Mount Sinai Civic Association against the town of Brookhaven and the developers of what was known as the Villages of Mount Sinai project. The civic association fought this massive development and was successful in significantly reducing the total number of units permitted under a court-ordered stipulation of settlement. Efforts on the part of the civic association forced the inclusion of a one-time donation to the Mount Sinai school district of $10,000 per unit to mitigate the tax impact of the project. Pictured here are, from left to right, Lori Anne Casdia-Diulio, Lynne Edsall, Ernie Bastiaans, town supervisor Felix Grucci, civic association president Lori Baldassare, and town councilman Eugene Gerrard.

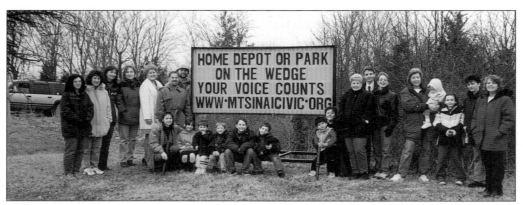

As part of ongoing beautification and land preservation efforts by the Mount Sinai Civic Association, funding provided by the state at the request of assemblyman Steven Englebright allowed the association to purchase a quarter acre of land on the tip of the wedge at the intersection of Mount Sinai-Coram Road, County Road 83, and Route 25A in 1999. In 1996, the Mount Sinai Hamlet Study Committee had recommended the development of a multi-use park and community center on this site. When Home Depot contracted to purchase the remainder of the property from owner Ed McGovern in 2000, community grass-roots support for the park led Suffolk County to purchase the 17-acre parcel for development as a park in 1991, in partnership with the newly formed nonprofit Mount Sinai Heritage Trust, headed by Lori Baldassare, Thomas Carbone, and Fred Drewes.

126

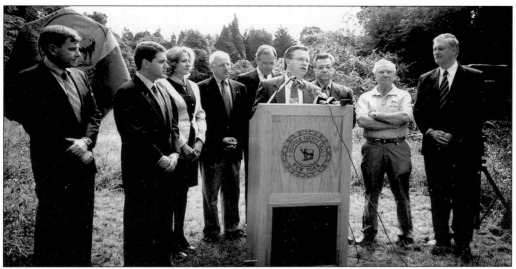

The Chandler Estate, located behind the Mount Sinai Congregational Church, between North Country Road and the harbor, was purchased by Suffolk County as parkland in May 2000. Environmental activists and the Mount Sinai Civic Association lobbied for the purchase for years. The preservation of this nearly pristine area encompassing coastal and island forest, tidal and freshwater wetlands, cliffs, bluff, and intertidal flats was recommended in the 1995 hamlet study. Plans for the property include use as a passive park and renovation of some of the buildings.

Little Portion Friary constructed a labyrinth, at the suggestion of Brother Clark Berge, in 1999. Labyrinths have been built and used by many religious traditions to allow people of all faiths to experience powerful meditative walks designed to foster spiritual contemplation. The labyrinth was designed by David Tolzman. The vision of a labyrinth at Little Portion became reality through the hard work of the brothers, who did the physical labor of construction, removing 18 truckloads of dirt and grass and spreading 10 truckloads of wood chips on the pathways.

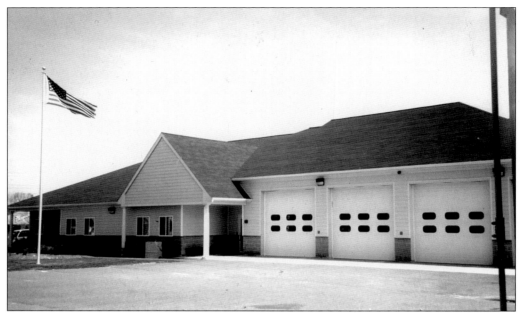

The Port Jefferson ambulance building was constructed on property acquired from the state in 2000. Formerly located on the grounds of the John T. Mather Memorial Hospital, the ambulance district, which encompasses Mount Sinai, Port Jefferson, and Belle Terre, moved to this more accessible location. Below is a "Welcome to Mount Sinai" sign erected by the Mount Sinai Civic Association in 1999. County legislator Martin Haley procured funds for the sign. The gazebo was donated by Gera Gardens and dedicated to the memory of Eileen Trombino, past president of the civic association, who died in 1995. The beautiful landscaping around the sign and gazebo were donated and are maintained by Kelly Brothers Landscaping.